MW00574886

POST
DATE

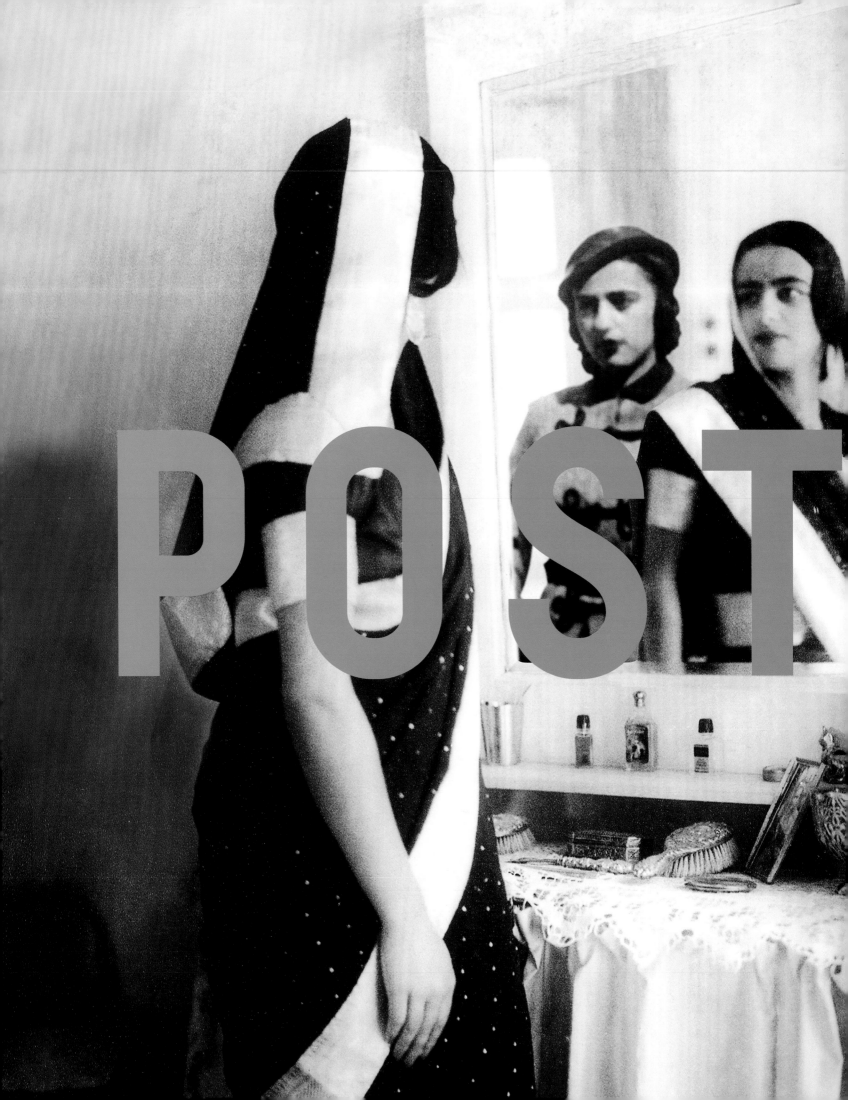

JODI THROCKMORTON

With Atreyee Gupta, Latika Gupta, Susan Krane,
and Raqs Media Collective

DATE

Photography and Inherited History in India

SAN JOSE MUSEUM OF ART

in association with

UNIVERSITY OF CALIFORNIA PRESS

Postdate: Photography and Inherited History in India accompanies the exhibition of the same name organized collaboratively by the San Jose Museum of Art, California, and the Ulrich Museum of Art, Wichita State University, Kansas, on view in San Jose from February 5 through August 2, 2015 and in Wichita from September 12 through December 15, 2015.

The San Jose Museum of Art gratefully acknowledges the following sponsors:

The Andy Warhol Foundation for the Visual Arts, New York

National Endowment for the Arts

Kaushie Adiseshan and Anand Rajaraman

Tad Freese

Mike and Yvonne Nevens

Dipti and Rakesh Mathur

Asian Cultural Council, New York

© 2015 San Jose Museum of Art

All rights reserved. This book may not be reproduced, in whole or in part, including illustrations, in any form (beyond that copying permitted by Sections 107 and 108 of the U.S. Copyright Law and except by reviewers for the public press), without written permission from the publishers.

San Jose Museum of Art
110 South Market Street
San Jose, California 95113–2383
www.sjmusart.org

Published in association with
University of California Press
Oakland, California

University of California Press, one of the most distinguished university presses in the United States, enriches lives around the world by advancing scholarship in the humanities, social sciences, and natural sciences. Its activities are supported by the UC Press Foundation and by philanthropic contributions from individuals and institutions. For more information, visit www.ucpress.edu.

Karen A. Levine, Senior Editor
Jack Young, Editorial Coordinator
Chalon Emmons, Production Editor
Janet Villanueva, Production Coordinator

The publisher gratefully acknowledges the generous support of the Art Endowment Fund of the University of California Press Foundation.

Library of Congress Control Number: 2014953125

ISBN: 978-0-520-28569-9

Coordinated and edited by
Terry Ann R. Neff, t. a. neff associates, inc., Tucson, Arizona

Designed and produced by
Amanda Freymann and Joan Sommers, Glue + Paper Workshop, Chicago

Color separations by
Professional Graphics, Rockford, Illinois

Printed in Hong Kong by Asia One

Front cover: Pushpamala N. and Clare Arni, *The Native Types—Toda (after a late nineteenth-century British anthropomorphic photograph)*, from the project "Native Women of South India: Manners and Customs," 2000–2004 (plate 5)

Back cover: Nandan Ghiya, *Female Indroid Album*, 2012 (plate 4)

Frontispiece: Vivan Sundaram, *Doppelgänger (Amrita, Simla, 1937; Amrita, Budapest, 1938, photo, Victor Egan)*, from the series "Re-Take of Amrita," 2001–2002 (plate 3, detail)

CONTENTS

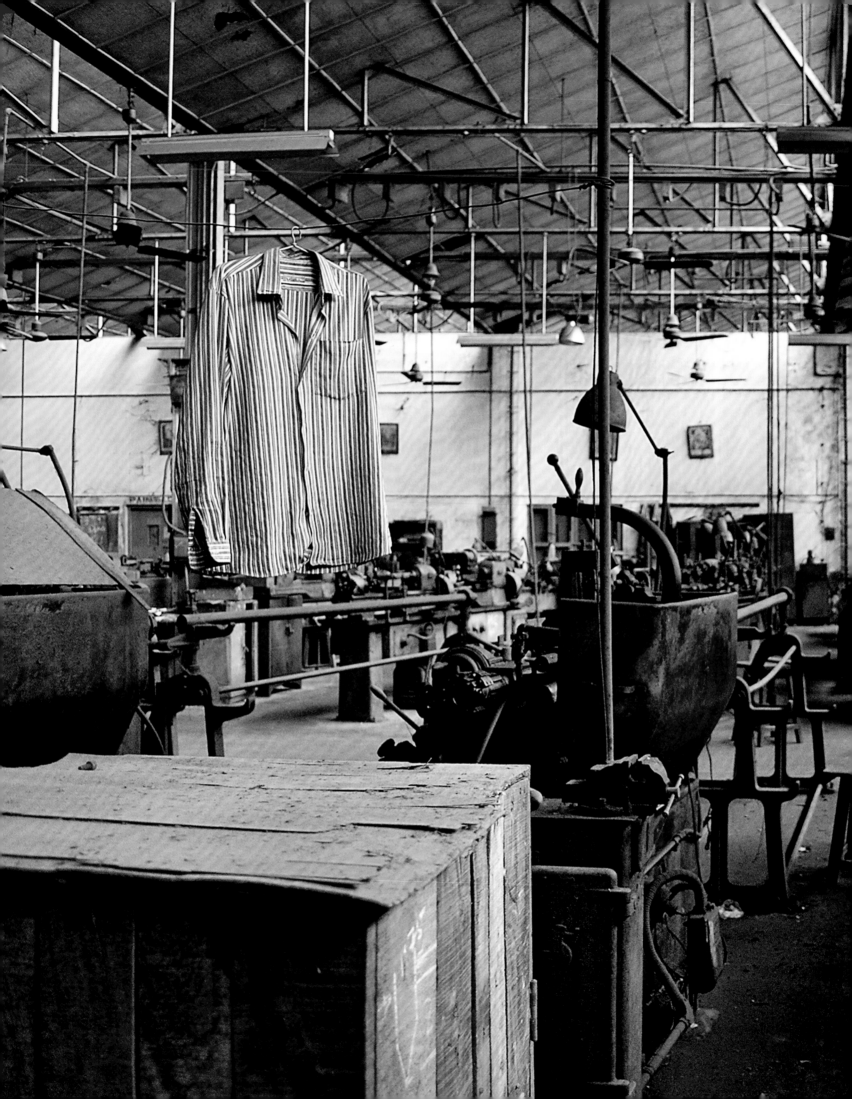

INTRODUCTION

On our first visit to Mumbai in 2012, Jodi Throckmorton and I set out for the Colaba gallery district from our hotel near the Gateway of India, the triumphal archway built by the British Raj at the southern tip of the city, on a jetty overlooking the Arabian Sea. The massive, four-story structure commemorates and monumentalizes the imperial visit of the king and queen in 1911.[1] Today encircled by a wildly busy and affluent tourist zone, harbor ferry terminals, and hawkers, it once served as the grandiose ceremonial landing point for colonial governors. Through this same gate, the last British infantry troops finally withdrew from the subcontinent of India after the Act of Independence, a departure that signified the end of nearly two centuries under British rule. This urban landmark— a top tourist attraction—arcs symbolically from the era of colonialism to that of twenty-first-century global consumerism.

The swarming crowds around the gateway quickly subsided as we walked south: cashmere and silk shops, high-end boutiques, international hotels, and hip restaurants gave way to a low-rise streetscape of weathered Victorian buildings, pocket industries, cobblestone back streets, storefronts overflowing with everyday wares, and sidewalks tight with vendors and workers and laborers.

It took us a long time to walk a rather short distance. The abundant visual distractions ranged from narrative street-art paintings tucked into back corners to the ubiquitous kiosks stocked with a profusion of flamboyant god and goddess prints, illustrated calendars, reproductions, and trinkets. The vivid popular imagery that envelops ordinary daily experience in India makes the United States seem whitewashed, denuded of visuality, in comparison.

Vernacular visual culture permeated our route to the cluster of contemporary art galleries located in south Colaba. Scattered among renovated warehouses and elegantly reclaimed upper-level rooms of assorted buildings,

these pristine "white cube" spaces are some of the country's leading and edgiest art venues. They operate on the global stage of the contemporary art circuit. The contrast between inside and out (like the inescapable imprint of the colonial past on the twenty-first-century city) was strikingly instructive—fluid rather than contradictory, simply an ambient reality. Could there be any more emphatic reminder of the concurrent flows of the local and the global that course, jointly rather than dualistically, through contemporary art practice in India as well?

Now, a few years later, it strikes me that the panorama of pop culture also provides a backdrop for *Postdate: Photography and Inherited History in India.* Photography as a medium, particularly photography with documentary intent, has distinct social significance and communal roots. It functions in a public space. It embodies and transmits political and social conditions.

The authors of this publication saliently place *Postdate* in the context of the "archival impulse," a strategic strain of international art activity identified by Hal Foster in his seminal essay "An Archival Impulse."[2] By reaching back in time and engaging in artistic conversation with historical photographs, these artists provide a new voice-over for images laden with the impacts of colonialism. Yet, in important contrast to Foster's examples, the loaded historical documents they address—then undress and redress—are often not at all "lost or displaced" or buried in archives. Their referents remain quite alive outside of the closeted realm of archives and beyond the parameters of contemporary art. In many cases, such imagery has entered the popular visual imagination—and lives on, for instance, through the omnipresent mass-produced depictions of Hindu deities and epics that are, to this day, often based on the oleographs published by the esteemed Victorian oil painter Raja Ravi Varma (1848–1906); through panoramic postcards; through tourist reproductions;

Madhuban Mitra and Manas Bhattacharya, *Untitled*, from the series "The Archaeology of Absence," 2009 (plate 9, detail)

through family photographs, common studio portraits, and snapshots; and through the stylistic conventions adopted by countless anonymous picture-makers.

History—especially the dominion of the colonial past—lies thick on the surface of the quotidian in India. For example, the prodigious painter Raja Ravi Varma was trained at a young age in traditional South Asia "water painting," and India's centuries-old legacy of narrative miniatures and court portraits. A national legend, he was the first Indian artist to cross into the European medium of oil painting and become world-renowned. Ravi Varma adopted the romantic pictorial conventions of the Victorian age and applied his highly refined technical skills to illustrating classic Hindu literature, notably scenes from the *Mahabharata* and *Ramayana*. His combination of genteel, academic European genre and Indian subject matter proved wildly popular and he started his own press to disseminate huge quantities of low-cost reproductions, both lithographs and lushly hued oil prints (oleographs). The great demand for his images continues still: they proliferate even as digital prints that can be ordered online at ravivarma.com.

Such popular source images may have shed the original circumstances and truths of their making—what anthropologist and art historian Christopher Pinney called "the micro-event of the making of the photograph."[3] Nonetheless, today they persist as ready-made templates of representation. They are not just artistic precedents for the artists in *Postdate*: as images, they belong to a national genealogy.

What makes the rich photographic legacy of India so important is the incursion of the medium's mute ghosts on present-day visual culture—and the magnitude of photography's role in the inheritance of history in India. *Postdate* is about an interplay between postcolonial contemporary art in India and the long echoes of colonial-era photography. Most of these artists are not photographers per se: photography is often merely one outlet of their work. The

formal qualities and techniques of historical photography are of only peripheral interest here. The subject matter rather is photography as information and evidence, as a reference point for a changing reality and as a script with which to play.

The aesthetic practices at hand in *Postdate* go beyond conceptual theoretical maneuvers or dry, historicizing analysis. These artists vacillate between subjectivity and objectivity; the presence of the self—a feeling and often humorous self—adds ambiguity and impact to their work. Gauri Gill befriends and mentors the girls she photographs, for years; Vivan Sundaram backdates his life, via collage, to coincide with his ancestors; Pushpamala N. and Annu Palakunnathu Matthew costume themselves and perform for the camera. These artists make viewers aware of the trigger-finger impulse of sentimentality, which is caught in the act. As Dr. Thomas Blom Hansen, director of the Center for South Asia at Stanford University, Palo Alto, California, noted when we discussed *Postdate* during its formative stages, the personal and at times domestic nature of this artwork makes it stand out from long-established postcolonial intellectual discourse. The issues may be well trodden; the visual vehicles and intimate voice of address are not and reach beyond academia.[4]

Interestingly, these very personal acts of image-recovery speak equally strongly to public space and civic life: the resultant artworks can be both poetry and proclamation. As art historian, critic, and curator Geeta Kapur wrote a generation ago, the struggle is one of "the history that Indians will make out of the history that has been imposed upon them. . . . For the creative artist, tradition takes the form of memory; the memory of experiences imbibed as much as lived."[5]

The San Jose Museum of Art is located in the midst of Silicon Valley, among one of the largest populations of South Asian origin in the United States and in a region

where cultural difference is in the majority. This group exhibition is the second to bring attention specifically to the work of Indian artists and to underscore the historical context and cultural framework for modern and contemporary Indian art—a topic of relevance to the museum's constituencies.

Geographically circumscribed projects like *Postdate* are open to curatorial debate: one artist in fact objected to her work being framed by a nation-specific exhibition and declined to participate. Her preference for the global (transnational and universal) over the local (parochial), however, also carries a charge. Globalization begets homogenization. The postcolonial theorist Homi Bhabha (born and raised in Mumbai) used the phrase "global cosmopolitanism" to describe the cultural marketplace's inclination to erase difference. He pointed to the fallout from uprooting work and thus depleting it of inherent and core meaning. Instead, Bhabha posited an alternative "vernacular cosmopolitanism." Other theorists proffer a spectrum of terms for the osmosis that occurs at the interface of local and global.[6] An exhibition such as this one is therefore purposefully only one of the ways SJMA has presented the work of South Asian artists: it exists alongside thematic shows that cast a broader international net, monographic exhibitions, and commissioned projects and acquisitions. *Postdate* is intended to bring to light the distinct ways in which these select artists engage with the complexities of postcolonialism and to foreground India's rich, powerful, and tellingly complex photographic legacy. It allows the museum to bring to its audiences a clear depth of field as we focus on the subject at hand—particular and especially pertinent to India.

Jodi Throckmorton approached this initiative with her special brand of curatorial rigor and her longstanding belief in open collaboration with artists. *Postdate* took shape through conversations and studio visits during two research trips she made to India while associate curator at the San Jose Museum of Art and through consequent discussions of concepts, content, and format among co-workers and peers. A project such as this raises complex questions for a Western curator with broad interests who—like many contemporary art museum professionals—is by definition a generalist rather than a specialist. It is intended to have wide public reach (for audiences of South Asian origin and those not) *and* to provide a significant framework from the perspective of the field of contemporary Indian art. Coming after the survey exhibition SJMA organized in 2011, *Roots in the Air, Branches Below: Modern and Contemporary Indian Art* (drawn exclusively from Bay Area collections), *Postdate* provides a meaningful thematic next step, with the potential to advance more specific knowledge and deeper critical awareness of the issues in the field. It follows the one-artist exhibitions *Beta Space/Ranu Mukherjee: Telling Fortunes* (2012–13) and *Jitish Kallat: Epilogue* (2013–14), which Jodi Throckmorton also curated. I thank her for the careful intelligence, diligence, and generative creative dialogue she has brought to this larger initiative—and for the great pleasure of hearing her think through her ideas over the past three years. Her ability to welcome many voices into the curatorial process is just one of the important contributions she made to the museum.

I thank Robert Workman, director of the Ulrich Museum of Art, Wichita State University, Kansas, for enthusiastically embracing this exhibition and working in partnership with SJMA during its final stages when Jodi Throckmorton was curator of modern and contemporary art there in 2013–14. *Postdate* would not have happened were it not for an initial professional travel grant from the Asian Cultural Council, New York, that enabled our first joint research trip, and a generous, early-stage grant from The Andy Warhol Foundation for the Visual Arts, New York, which supported this publication. I am most grateful to Kaushie Adiseshan and Anand Rajaraman; trustee Tad Freese; trustee Mike Nevens and Yvonne Nevens (who also provided critical curatorial support); and trustee

Dipti Mathur and Rakesh Mathur for their extraordinary sponsorship of *Postdate* and for their enthusiastic participation and assistance from the beginning. The fundraising process has never been more fun.

This handsome book is the result of collaboration with the University of California Press, and I thank Kim Robinson, editorial director; Kari Dahlgren, acquisitions editor, art history; and her successor, Karen Levine, for the pleasure of the co-publication process. Terry Ann R. Neff of T. A. Neff Associates is far more than an extraordinary museum editor: she is an in-the-trenches friend to every author and a project manager who brings clarity and confidence to even the most pressured of production schedules. We were honored to work with Terry and Glue + Paper Workshop, Chicago, who made this book as enticing as the art and words therein.

Susan Krane
Oshman Executive Director
San Jose Museum of Art

1 When he landed in Mumbai in 1911, the recently crowned King George V was the only British monarch to have ever visited India, the empire's most heavily populated and precious colony. He and Queen Mary held the titles of Emperor and Empress of India. However, the Gateway of India was finished years later, in 1924, in a revivalist architectural style and at a time when nationalist movements were rapidly gaining force under Ghandi's leadership.

2 Hal Foster, "An Archival Impulse," *October* 110 (fall 2004), 3–22, esp. 4.

3 Christopher Pinney, "Coming Out Better," in *Where Three Dreams Cross: 150 Years of Photography from India, Pakistan and Bangladesh* (Gottingen: Steidl; London: Whitechapel Gallery; Winterthur: Fotomuseum Winterthur, 2010), 26.

4 As an academic discipline, postcolonial studies probe the residual, implanted consequences of colonial rule and look at the ways such past occupation and domination continue to affect nationhood, culture, and the individual. South Asian scholars, notably Homi Bhabha, have played leading roles in the field.

5 Geeta Kapur, "Introduction," in *Contemporary Indian Artists* (New Delhi: Vikas Publishing House, 1979), www. aaa.org.hk/Collection/ CollectionOnline/SpecialCollectionitem/6659#, 5.

6 For example, see Pnina Werbner, "Vernacular Cosmopolitanism," *Theory, Culture, & Society* 23, 2–3, 496–98.

ACKNOWLEDGMENTS

Postdate: Photography and Inherited History in India would not have been possible without the support and hard work of many people. My deepest thanks go to the artists: they were extraordinarily generous with their time, as well as their art. Ideas for this exhibition and book grew from conversations with Gauri Gill and Raqs Media Collective, who patiently worked with me at a time when my enthusiasm and curiosity outweighed my knowledge of their work. Raqs graciously contributed an essay and created a special commission for this catalogue, both of which give unique insight into their artistic practice. I would also like to acknowledge the other contributing authors: Atreyee Gupta for a thoughtful essay that offers a provocative historical perspective and for giving me invaluable advice on the project; and Latika Gupta, for her carefully researched and crafted entries on the artists. I am particularly appreciative of the encouragement and wisdom of Susan Krane, Oshman Executive Director, San Jose Museum of Art, who inspires me as a writer and has built my confidence as a curator. In addition to her work behind the scenes, she has contributed an insightful introduction to the book.

Foundational support from The Andy Warhol Foundation for the Visual Arts, as well as early research travel support from the Asian Cultural Council and critical support from the National Endowment for the Arts made this publication possible. I am grateful to the individuals and institutions who have graciously loaned works to the exhibition: the artists; Exhibit 320, New Delhi; Dipti and Rakesh Mathur; Nature Morte, New Delhi; Photoink, New Delhi; San Jose Museum of Art; sepia EYE, New York; and the Ulrich Museum of Art, Wichita State University, Kansas. I would like to especially thank Dipti Mathur, who not only loaned works from her collection, but also shared with me her vast knowledge and enthusiasm for Indian art.

I thank the hard-working staffs at the San Jose Museum of Art and the Ulrich Museum of Art including Ulrich director, Robert Workman, who gave me unwavering support on this project. I thank him for bringing this exhibition to Wichita and for allowing me to take the time I needed to work on it. At the Ulrich, I'd like to specifically thank Carolyn Copple, Jessy Clonts Day, Linda Doll, Jana Durfee, Amy Hopper, James Porter, and Stephanie Teasley. At SJMA, Anamarie Alongi, Sherrill Ingalls, Rich Karson, Lucy Larson, and Carol Pizzo all gave generously of their time and expertise. Also, thanks go to the development staff (under the leadership of Lisa James) for their successful efforts in fundraising for this project. Deputy Director Deborah Norberg was invaluable. Her cheerful disposition and "can do" work ethic got us through the difficult times and I will be forever grateful for her hard work and dedication.

The success of this publication is largely due to Terry Ann R. Neff, who carefully edited and organized the book while calmly teaching this inexperienced author the ins and outs of publishing. Stephanie Battle braved miles of red tape to collect images and secure reproduction rights. Thanks to the staff at University of California Press, who saw this book through to publication, and Glue + Paper Workshop for their elegant design and production oversight.

My heartfelt thanks go to my mother, Doris McLean, who used her prowess as an English teacher to edit my papers as a student and emboldened me to travel and be curious about the world. And, of course, special thanks to my husband, William Fisher, who manages to keep me happily focused and laughing.

Jodi Throckmorton
Curator of Contemporary Art
Pennsylvania Academy of the Fine Arts
(formerly Curator of Modern & Contemporary Art, Ulrich Museum of Art, Wichita State University, Kansas, 2013–14)

ESSA

Y S

JODI THROCKMORTON

Photography and Inherited History in India

Two generations after the exultation of hard-won independence in 1947 and the concurrent horrors of the Partition of India into India and Pakistan, the artists represented in *Postdate: Photography and Inherited History in India* are paving the way for a new generation of Indian thinkers who are reclaiming and re-appraising the history of their country. These artists look closely and critically at the distinct history of Indian photography from the early days of the medium and at the height of the British occupation of the subcontinent in the nineteenth century to contemporary digital practices. Their sources are diverse: panorama photographs that document the development of Mumbai (then Bombay) in the mid-nineteenth century; hand-painted studio portraits from the early twentieth century; stills from Bollywood movies. The artists take history into their own hands, redefining iconic images of India and investigating the complex relationship between traditions of representation and contemporary practices of image-making. This group critically consider the nature of historical methods and whether or not the results can be trusted; the influence of the global and the draw of the local; and, through the use of digital technology, alternate ways of thinking about history and its relationship to today. Their

observations are particularly germane to understanding global contemporary art practices that embrace tradition and innovation as covalent rather than competitive forces. There are artists around the world who are interested in history—addressing history in artistic practice is neither a new mode of working nor a phenomenon that exists only in India. However, the way these artists are considering the weighty issues of colonialism and its relationship to a wide span of the history of Indian photography warrants a specific look.

This increased interest in understanding and organizing the history of photography in India occurred concurrently with the rise of the contemporary art market in the country and globally. Increasingly engaged in the international market, artists are acutely aware that the representation of India is often limited to photographs of the Taj Mahal or of disconcerting poverty in urban slums. Also, as Ram Rahman noted:

There has been a growing debate in Indian art circles on a "Biennale aesthetic" being imposed on art practice here which is leading to production of work that is slick, easily slotting into a new Orientalism, now in its consumerist global market

avatar. In photography circles, the previous generation was accused of being purveyors of an "exotic" fakir-filled India steeped in colourful riverside rituals, or quaint Bollywood—that was the India in demand around the world. Is it then surprising that the demand for images now is for the "new" middle class and elite young India—consumers of Chanel, Nokia, Honda, readers of Indian editions of Elle, Conde Nast Traveller or L'Officiel? Do these images provide a reassurance that the world is becoming less complex and differentiated and more comfortably mono-cultural?[1]

The artists in *Postdate* are well aware of the whiplash-inducing debate between globalized aesthetics and images that perpetuates a one-dimensional understanding of Indian culture such as Rahman described. As a consequence, they seek to go beyond simplistic delineations and definitions such as global versus local and Western versus non-Western by including their commitment to located histories in India within their engagement in transnational discourse.

Inherited History

Photography was invented in 1839 in Europe, and by the 1850s it was firmly established commercially and artistically. Driven by the population of British colonials in India and the desire of their compatriots at home for images of this foreign and "exotic" land, photographers (both British and Indian) focused their lenses on indigenous populations and customs, architecture and monuments, and street scenes and landscapes. Indians often worked for the British. They learned photography from them and later opened their own studios (for example, Lala Deen Dayal) or used the medium for creative expression (Umrao Singh Sher-Gil). India's First War of Independence in 1857 was one of the earliest extensively photographed wars in the world.

Though photography was present in India since its invention, critical writing and attempts to chronicle its history have been made in earnest only within the last thirty years. Concurrently in the 1990s, the Alkazi Foundation for the Arts, a collection of over ninety thousand nineteenth- and early twentieth-century photographs from South and Southeast Asia, began to archive its vast collection.

Photography makes history visible. It taps into our innate need to look at each other face-to-face. Likely due in large part to the burgeoning scholarship and recent attempts to categorize and collect these archival images, many of the artists in this exhibition are mining the rich tradition of photography in India in order to rethink dominant historical narratives, share hidden stories, and, ultimately, to make a personal connection with the history of their country. This human connection to history is often at the forefront of their work. However, instead of assuming that a photograph is a representation of truth, they often take to task the structure through which history is validated and question the motives underlying the image. Although all history is "inherited," these artists seek to better understand what has been passed on and move forward with it into the future. In the case of this project, the term "postdate" refers to the artists' marking vestiges of the past with ideas from the present. This approach is an unmooring of history that, in the artists' movements both backward and forward in time, reveals the unsettled nature of this history.

Raqs Media Collective's work has been very important in defining the key concepts of this exhibition. They have been at the forefront of artists working globally with photographic archives and are engaged specifically with the history of photography in India. Their considered extension of the role of the artist into archival science and historical fields of study finds expression in the multimedia and multigenre nature of their installations. They dismantle existing historical frameworks to question our understanding of past events and to suggest alternative

narratives. Hal Foster stated that this type of work "not only draws on informal archives but produces them as well, and does so in a way that underscores the nature of all archival materials according to a quasi-archival logic, a matrix of citation and juxtaposition, and presents them in a quasi-archival architecture, a complex of texts and objects (again, platforms, stations, kiosks. . .)."[2] Raqs noted that *The Surface of Each Day is a Different Planet* (2009) (see Raqs, plates 3–5), a video piece in which they combined historic photographs from archives in London and New Delhi with contemporary imagery and animation, is purposefully antidocumentary, as well as nonnarrative. They asked, "Can there be a time made of juxtapositions, a time never experienced, but made serendipitously manifest by interpretative accidents? By the careful cultivation of chance encounters in scattered archives?"[3] Though Raqs's practice is grounded in historical research, the ideas, objects, photographs, or statements they choose to extract or derive from the archive are creatively combined and considered to engender new theories and histories.

Whereas Raqs Media Collective works from existing material, Madhuban Mitra and Manas Bhattacharya very intentionally label their photographs and videos of the empty National Instruments Ltd. camera factory an archive. This factory in the Jadavpur neighborhood of southern Kolkata marks a national attempt to democratize image-making in India. The National 35 was India's first locally made, low-cost camera. It was popular throughout the 1980s, but this government-owned venture began to decline and the factory was closed in the 1990s.[4] Mitra and Bhattacharya's images (see Mitra and Bhattacharya, plates 1–11) of the factory tell the story of an important moment in Indian photography. Their pictures reflect upon the histories of labor, photography, and technology in India. Furthermore, they exemplify the act of photography looking at itself—in this case, specifically, digital photography looking at its analogue version. The artists are less interested in the photograph as document (though they

intend their archive to be a lasting record of the factory) than in technological development within the medium. In using digital tools, they simultaneously embrace the newest developments in the medium and nostalgically mourn the failure of a camera company.

Surekha and Pushpamala N. both use old photographs to examine the photographic representation of women in India. While Pushpamala is interested in the iconic images of Indian womanhood, Surekha creates installations from vernacular studio and wedding photographs that she finds in Bangalore, the city where she currently lives. In *Fragments of a Wedding Diary* (see Surekha, plates 1–4), Surekha digitally reframed and colored fragments of found wedding photographs and negatives from the 1960s–90s in order to highlight the ritual and physical aspects of a wedding. By fragmenting these photographs (see Surehka, plate 3), she removed them from a specific personal context and created an installation that reflects upon the place of wedding photography in collective memory. Additionally, in regard to the artifice of photography, she noted that, "the common people become the lead actors during their auspicious wedding day. The marriage photographs or/and the marriage videos document a specific culture of people. It is also a document of what they essentially are not in their true life."[5]

Rochana Majumdar's question about nineteenth-century wedding photography in Christopher Pinney's *The Coming of Photography in India* strikes a similar chord: "How [are we] to understand Bengali wedding portraits, most of which show the bride and bridegroom . . . often with their limbs touching, their images frozen in a gesture of togetherness when other histories seem to suggest that these sentiments were far more contested in everyday life?"[6] This contradiction between photographic convention and the history of married relationships in India is at the core of Surekha's investigation into this particular vernacular photography in South India. The contrived nature of wedding and portrait photography, in this instance, is

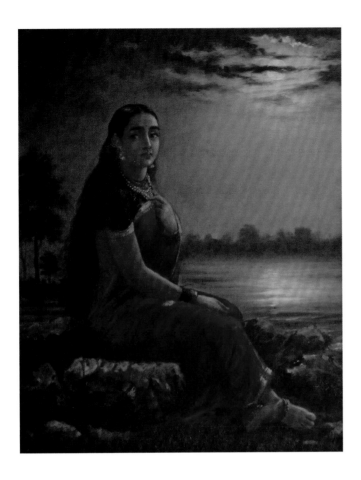

FIGURE 1
Raja Ravi Varma (Indian, 1848–1906)
Lady in the Moonlight, 1889
Oil on canvas
29 ½ x 23 ½ inches
Courtesy of the National Gallery of Modern
Art, New Delhi

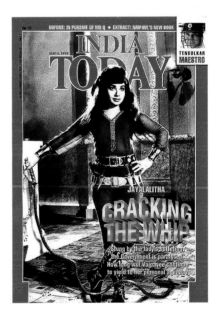

FIGURE 2
Jayalalitha in action role, cover of
India Today, May 4, 1998
Source: *India Today* dated May 04, 1998
Copyright © 2014, Living Media India
limited. All rights reserved

a barrier to clearly understanding the position of women in this region. Her emphasis on the formal similarities of these photographs prompts a consideration of past and present women's rights issues.

In her series "Native Women of South India: Manners and Customs," Pushpamala investigated the roles of subject and photographer by enacting historical images such as Raja Ravi Varma's nineteenth-century paintings of graceful, sari-clad women (figure 1) and 1920s film stills featuring mysterious ingénues (figure 2). In collaboration with Clare Arni, a British photographer who has spent most of her life in India, Pushpamala carefully created sets that replicated scenes from these quintessential images and cast herself as the archetypes. As Pushpamala intended, this exactness leads to a final photograph that is obviously artificial. Geeta Kapur noted in reference to this series, "An obsessive mimesis can render the repetition in mimicry a measure of calibrated *difference*—visual, cultural, anthropological—mocking yet enhancing representation."[7] In so deliberately performing these tableaus, the artist calls attention to the artificial nature of the conception and creation of the source images. For example, *The Native Types—Toda* (see Pushpamala N. and Clare Arni, plate 5)

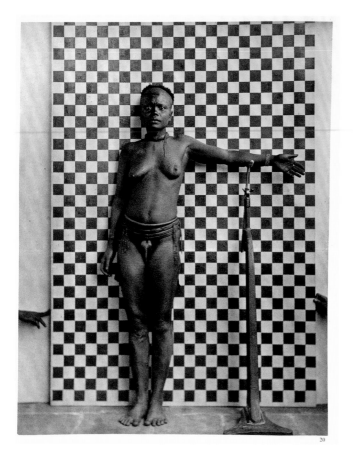

FIGURE 3

Maurice Vidal Portman (British, 1860–1935)

Keliwa Woman of Ta-Keda Tribe, Age about
45 Years, ca. 1893

Platinum print

13 ½ x 10 ½ inches

The British Library, Oriental & India Office

Collection photo 188/11 (20)

refers to British colonial ethnographic photography from the nineteenth century, specifically a series by Maurice Vidal Portman in which he measured and photographed people of the Andaman Islands against black-and-white checkered backdrops (figure 3). One may initially assume that the hands holding the backdrop in *Toda* were an addition by Pushpamala to emphasize the artifice and demonstrate the control that the British colonial photographer would have had over the native, but hands were present in Portman's ca. 1893 photograph. In re-enacting such a wide span of Indian photographic history in this series, Pushpamala called attention to the consistent and continued presence of colonial legacies in photographic practice.

Beyond Global Influence and Local Perspectives

In specifically looking back at India's photographic past—images that reflect important moments of local history and customs while simultaneously recalling the legacy of colonialism—the artists in this exhibition assert the necessity of engaging with both the global and the local in their work. As Frederick Gross suggested in his essay "Contemporary Photography Between the Global and the Local," "a new model of interpretation based upon [Homi K.] Bhabha's situation of a 'vernacular cosmopolitanism' in which an artist is critically aware of the effects of globalization within the distinctive worldview of his or her own localized cultural identity"[8] is needed. The artists presented here seek to acknowledge but deconstruct this narrow representation to create work that reflects the complex hybridity inherent to a globalized India.

With awareness of the global art world and keeping in mind the inclinations of past photographers in India toward the exotic, these artists take a personal approach to determining cultural identity from both global

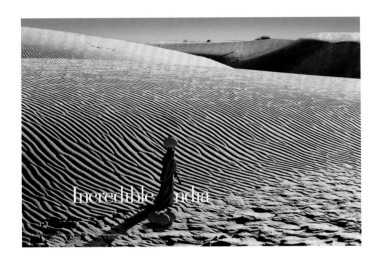

FIGURE 4
Image from "Incredible India" campaign,
2002–2003
Courtesy of the Ministry of Tourism, Government
of India, New Delhi

and local perspectives. Gauri Gill, for example, who is based in New Delhi, is conscious of her outsider status when addressing the complicated and contradictory elements of contemporary life in India's rural Rajasthan. She explores these issues by engaging with the problematic history of representation in rural Indian portrait photography. Her approach is collaborative and activist. In 2003, she set up a makeshift studio at a Rajasthani fair for young women and girls and invited them to be photographed "as they are, or as they see themselves, or to invent new selves for the camera."[9] This attitude is in striking contrast to the methods of the photographer in nineteenth-century India who, as Christopher Pinney outlined in *Camera Indica: The Social Life of Indian Photographs*, often carefully controlled the costumes, poses, and props of his subjects so as "not to capture in his negatives the complex contemporary hybrid reality he encountered, but rather to stage a vision of an authentic primitiveness salvaged from imminent extinction."[10] Gill, on the other hand, in allowing the natural hybridity of Rajasthani culture to come through in her photographs, refuted historical and contemporary photographic practices that emphasize the exotic "otherness" of their subjects. Traditional *salwar*

kameezes appear alongside modern t-shirts and blue jeans—indicative of the tensions of change but also co-existence. Moreover, initially Gill took only black-and-white photographs of Rajasthan with the idea that eliminating color would likewise reduce the romanticized identity of the country. Anita Dube pointed out that Gill's photographs are a much-needed counterpoint to the visions of Rajasthan promoted by travel campaigns such as "Incredible India" (figure 4).[11] Gill's decision demonstrates that she (along with many other artists in this exhibition) is alert to how her photographs are interpreted both inside and outside of India. As David Batchelor argued, Western culture has long rejected color and associated it with "the feminine, the oriental, the primitive, the infantile, the vulgar, the queer or the pathological."[12]

Jitish Kallat is also interested in how global culture has shaped local experience. Like Gill, he seeks to show India's complex relationship with globalism. The changes to India's cities—both good and bad, from better housing to air and water pollution—reflect the changes of pace and ideology of the country and Kallat's work demonstrates these complexities. Inspired by the panoramic documentation of the development of Mumbai (figure 5) in the boom time of the 1800s, Kallat created a modern-day

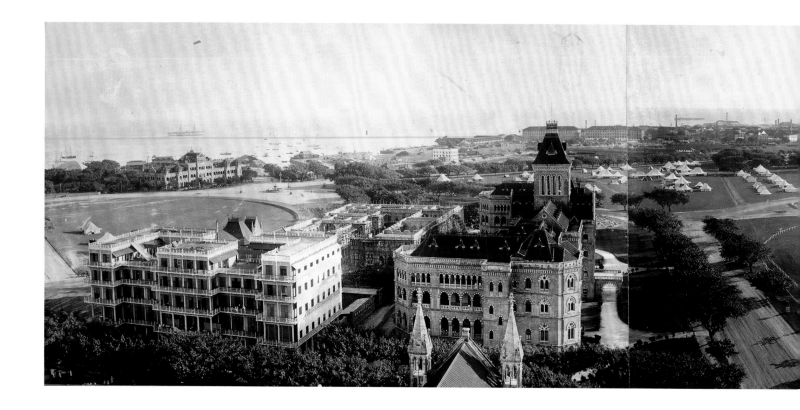

panorama of Mumbai by digitally layering multiple time frames within a single image. Whereas the early panoramas sought to capture the changing skyline and the erection of colonial-style buildings, Kallat sought to capture the pace of a twenty-first-century city. The title of the photograph *Artist Making Local Call* (see Kallat, plate 1), for example, refers to the fact that the photograph's exposure time matched that of the average local call on a pay phone—one and a half minutes—an act performed by the artist and recorded in the center of the photograph. Kallat's phone call provides the focal point within the surrounding chaos and comments on how a global impetus affects a city. He collapses time and space in his panoramic cityscapes in order to catch a glimpse of the present before it fades speedily into the past. His digital layering offers an apt metaphor for the convergence of years passing and the changing architecture of a city. Unlike the historic "frozen" panorama, Kallat's photograph reels forward into the future with people and rickshaws meeting and colliding across time around him.

Though she spent much of her life in India, Annu Palakunnathu Matthew is the only artist in the exhibition who does not currently live there. Matthew uses performance in her photography to better understand her experience as an immigrant to the United States and to reveal the connections and similarities between the photographic histories of the two countries. In her series "An Indian from India," she investigates the connection between the representation of native Indians and Native Americans in photography from the nineteenth and early twentieth centuries. With a distinctively South Asian and female perspective, she reenacts iconic photographs of Native Americans—including famous examples by Edward S. Curtis (see Matthew, plate 10)—and prints them directly next to the original image on a sheet of paper. Her titles for the photographs comment further on stereotypes and bring this historic discussion into the present. For example, in *Feather/Dot,* she paired a photograph of a Native American wearing a feather headdress with an image of herself wearing a symbolic *bindi* dot (see Matthew, plate 5). As Matthew noted, "It seems strange that all this confusion started because Christopher Columbus thought he had found the Indies and called the native people of America collectively as Indians."[13] Matthew's work reminds us that five-hundred-year-old "confusions" can still influence global identity politics. Like Pushpamala N., her mimicry points to the artificiality of photography and the heavy hand that photographers such as Curtis had in manipulating their supposedly "documentary" photographs of native people.

FIGURE 5

Lala Deen Dayal (Indian, 1844–1910)

View of Bombay from Rajabai Tower, ca. 1890

Two-part panorama on printing-out paper

6 x 20 ¼ inches

The British Library, Oriental & India Office

Collection photo 784/1 (35)

Digitally Connecting Past and Present

Digital technology has proved to be a strong force in the globalization of culture. India has become one of the countries most often associated with the "digital divide"—a disparity between those who have access to information and communications technologies and those who do not. Though this is a worldwide issue, the striking difference between the well-connectedness of its elite and the living conditions of its poor makes the disparity in India especially conspicuous. The artists in *Postdate* use digital technology to connect past and present concerns, as well as to consider its impact on local culture. Their work reflects the formation of a new aesthetic language that has been greatly influenced by our near constant interactions with computers and smartphones.

Organizations such as the 1947 Partition Archive, based in Berkeley, California, use digital technology and the Internet to collect and share the stories and experiences of Partition. As fewer people remain who experienced Partition first-hand, capturing their stories becomes more urgent. Digital technology has created the opportunity for these stories to be collected on a massive scale—numbering to date more than one thousand oral history interviews.[14]

Matthew's recent work echoes this desire to capture these experiences, yet also, through digital technology, to connect generations. Despite having spent the majority of her childhood in India, Matthew felt vastly uninformed about the 1947 Partition. In an effort to better understand the impact of this historic moment on the citizens of India and Pakistan, in 2012, as part of a Fulbright Fellowship, she began to collect portraits from the late 1940s from families who were affected by the division. She then photographed subsequent generations of these families and digitally brought the images together into one morphing animation (see Matthew, plate 11). The animations conflate past and present and connect the personal with the political—a connection emphasized by the placement of the personal video stories in an English-language encyclopedia that discusses the geo-political impact of Partition. Matthew creates a memory that exists only in the digital world. She "re-orient[s] the viewer's connection to time as [she] collapse[s] the presumed progression of its borders, so the past and present appear here in the same virtual space"[15] and calls attention to the shifts between generations by making the family photograph into a conduit through which geo-political shifts can be observed.

Vivan Sundaram uses digital means to expand upon and create new narratives from his family's photographic

archive. Sundaram's family history is deeply intertwined with the history of art in India. His aunt Amrita Sher-Gil was a prominent modern artist and his grandfather Umrao Singh Sher-Gil was a great scholar and pioneer of photography. In his "Re-Take of Amrita" series, Sundaram collaborates posthumously with his grandfather by digitally layering family images taken at different times and places into single photographs. He creates new narratives for the family, chiefly around Amrita Sher-Gil. Nicolas Bourriaud applied the term "postproduction" to artwork that has been created from already existing pieces, noting that, "This art of postproduction seems to respond to the proliferating chaos of global culture in the information age. . . ."[16] He likened the artist to a DJ—remixing parts and pieces to create a new work of art. Certainly this is true for Sundaram's series, albeit filtered through a much more personal lens. As he warps time and space, Sundaram also disrupts the notion that a photograph is a fixed, and thus truthful, document. In fact, he calls these photographs "future" works of art[17] —perhaps because they cannot be anchored to a specific time or place. The artist pushes even further, calling into question the entire narrative by purposefully leaving footprints of his digital tools—blurring or color variation—to show that changes have been made (see Sundaram, plate 7).

Nandan Ghiya similarly emphasizes the traces of his tools. He paints nineteenth-century studio portraits to make them look as if they have been digitally manipulated, then groups them in salon-style installations. For example, his *Chairmen* (see Ghiya, plate 1) brings together photographs of Indian men in business attire posing in front of commercial studio backdrops. Like Surekha's installations of found photographs, Ghiya's groupings sort specific categories of vernacular photographs and thereby call attention to cultural connections, as well as stylistics related to studio portraiture. Ghiya, however, uses the now global language of digital technology to further separate the viewer from the people in the portraits. For

example, by painting pixels on the faces of the individuals, he obscures their identity and creates a sense of anonymity. In doing so, he intentionally frustrates the viewer and calls attention to the unknown or unreachable aspects of history. Given our access today to unlimited information thanks to the Internet, such frustration feels particularly acute. Ghiya's barriers of pixels and download errors raise questions about the idea that one can fully understand the world through digital means.

Taking on the Future

India's history of photography has proved to be a bountiful source for artistic investigation. The artists represented in this exhibition take a multidisciplinary approach to exploring cultural representation, methods of chronicling history, and the effects of globalism on their country. In old photographs and archives they find stylistic similarities that reveal larger questions about Indian society and make surprising, thoughtful, juxtapositions that call into question the authority of historical structures. By engaging with both local history and the larger world, they reveal complex intersections between the past and present; rural and urban; and Western and Indian cultures. Using new digital tools, they find ways to suggest narratives that offer alternatives to dominant historical perspectives and stereotypes.

Pushpamala N. succinctly summarized the demanding roles of contemporary artists in India: "In a postcolonial country like India, artists have seen their role as developmental and have worked to build institutions and the infrastructure for creative life to flourish. The artists I admire are scholar-writer-teacher-artists. I believe the creative subjectivity and the anarchic individualism of the artist resist the homogenous culture demanded by both a feudal society and by a globalizing world!"[18] Ultimately, the artists in *Postdate* exemplify this model: they are researchers,

collectors, activists, genealogists, performers, and docu-mentarians. They engage with the history of photography in their country in order to better understand the lasting legacy of colonialism on contemporary culture. Engaged globally and locally, they have a large role and consider-able responsibility in defining and developing the post-colonial artistic culture in India and representing the history of their country to the world.

1 Ram Rahman, "A Sharper Focus," accessed August 13, 2014, http://www.india-seminar.com/2007/578/578_ram_rahman.htm.

2 Hal Foster, "An Archival Impulse," *October* 110 (2004), 5.

3 *Raqs Media Collective: The Surface of Each Day is a Different Planet*, exhibition announcement, accessed July 23, 2014, http://e-flux.com/announcements/raqs-media-collective-the-surface-of-each-day-is-a-different-planet/.

4 Anustup Basu, "'Through a Lens Starkly': An exploration of JU Medialab's National Instruments Project archive," in *InterMedia in South Asia* (London and New York: Routledge, 2012), 101.

5 Surekha, artist statement, accessed March 24, 2014, http://surekha.info/fragments/.

6 Christopher Pinney, *The Coming of Photography in India* (London: British Library, 2008), 144.

7 Geeta Kapur, "Gender Mobility: Through the Lens of Five Women Artists in India," in *Global Feminisms* (Brooklyn, New York: Brooklyn Museum, 2007), 85.

8 Frederick Gross, "Contemporary Photography Between the Global and the Local," in *Global and Local Art Histories* (Newcastle, United Kingdom: Cambridge Scholars Publishing, 2007), 43.

9 Gauri Gill, *Balika Mela: Gauri Gill* (Zurich: Edition Patrick Frey, 2012), 163.

10 Christopher Pinney, *Camera Indica: The Social Life of Indian Photographs* (Chicago: The University of Chicago Press, 1997), 46.

11 Anita Dube, "The Desert Mirror." *ARTIndia* 15, 1 (Quarter 1, 2010).

12 David Batchelor, *Chromophobia* (London: Reaktion Books, 2000), 22–23.

13 Annu P. Matthew, artist statement, accessed March 24, 2014, http://www.annumatthew.com/artist%20statement/Indian_statement.html.

14 1947 Partition Archive website, accessed July 24, 2015, http://www.1947partitionarchive.org/browse.

15 Annu P. Matthew, artist statement, accessed March 24, 2014, http://www.annumatthew.com/Portfolioregeneration/Regeneration_statement.html.

16 Nicolas Bourriaud, *Postproduction* (New York: Lukas & Sternberg, 2002), 4.

17 Vivan Sundaram, *Vivan Sundaram: Re-take of Amrita* (New Delhi: Tulika Books, 2001), 5.

18 Pushpamala N., *Pushpamala N.: Indian Lady* (New York: Bose Pacia, 2004).

ATREYEE GUPTA

Belatedness and Simultaneity: A Short History of Photography from India

The metaphor of time invoked by the title of this exhibition, *Postdate*, offers an invitation to probe the question of temporality in relation to photography in India. The point of entry is straightforward: contemporary photography from India, as in the works included in this exhibition, presents a visible dialogic relationship between the contemporary and the historical. For the gestures undertaken by these artists serve as a form of insurgency that uncovers, often through re-enactment and manipulation, multivalent desires and subjectivities that operated, and continue to operate, in photography's historical archives.

Such gestures may be recognized as belonging uniquely to the contemporary. Indeed, they find resonance in what Hal Foster has described as an "archival impulse"—a tendency within contemporary art "to make historical information, often lost or displaced, physically present."[1] It registers the demand, as Foster put it, "to turn belatedness into becomingness, to recoup failed visions in art, literature, philosophy, and everyday life into possible scenarios of alternative kinds of social relations."[2]

On one level, this has much to do with an ongoing hermeneutic engagement with art and history to make it productive, once again, for our contemporary use. On another level, the belatedness and becomingness that Foster described contain a certain conception of the modern, one that is articulated in relation to modernism's privileging of reason, order, and fictive assumptions of wholeness. In contrast, assuming fragmentation as universal, the new archival impulse registers a utopian demand for a range of affective associations and elective solidarities. "This partial recovery of the utopian demand is unexpected," Foster noted. "Not so long ago this was the most despised aspect of the modern(ist) project, condemned as totalitarian gulag on the Right and capitalist *tabula rasa* on the Left."[3]

In the South Asian context, the utopian politics favored by elite agents of decolonization were certainly modernist in essence. Such assumptions faced vigorous critique from the 1970s onward and, by default, an extensive matrix of modern aesthetic practices were disbarred

from scrutiny. Thus, in South Asia, there exists a range of modern artistic practices but little critical history for it. It necessarily follows that the relationship to the modern remains messy, incomplete, and unresolved, perhaps more in some parts of the world than others.

To think about the archival impulse, it therefore appears necessary to place the modern at the center of investigation in a way that can both critique and recover it for contemporary uses. Belatedness and becoming hold a peculiar resonance for the subcontinent's art as much as a sense of the past, history, and temporality under-pin conceptualizations of the contemporary. But at the same time, the history of photography in South Asia also short-circuits the question of belatedness that too often still remains internal to discussions on modern art of the subcontinent.

The daguerreotype found its way to India almost immediately after its discovery was formally announced at a meeting of the Académie des Sciences in Paris on August 19, 1839. From 1840 onward, advertisements for daguerreotype cameras had already begun to circulate in the subcontinent. The first salon exhibition devoted solely to photography took place in Mumbai on February 2, 1856, only four years after a similar exhibition at the Royal Society of Arts in London.

Although this early history is now well known, three short vignettes, spaced across time, can illuminate some of its lesser-known coordinates. The first vignette focuses on the late nineteenth and the early twentieth centuries; the second on the closing years of the interwar period; while the third targets the decades following the Second World War. All too often, transcultural globality is viewed as uniquely associated with contemporary times, thereby squarely placing the modern within nation-centric territorial configurations. However, there was an interconnected, indeed transcultural, world that photographers in India shared with their contemporaries elsewhere.

Vignette One: Chicago, ca. 1893

In 1893, the Mumbai-based photographer Shapoor N. Bhedwar delivered a lecture on portraiture at the Congress of Photographers, organized in conjunction with the World's Columbian Exposition in Chicago. After a failed career in literature and a stint with Mumbai's Parsi Eleven cricket team, Bhedwar had set off in 1889 to study pho-tography at the Polytechnic School in London.[4] In 1890, he launched his career with his photogravure series "Feast of Roses" in a London Photographic Salon exhibition (fig-ure 1). Pictorial photography was Bhedwar's preferred genre, perhaps because of his literary interests and his familiarity with the conventions of academic painting exemplified by the late nineteenth-century Indian oil painter Ravi Varma. Bhedwar developed an intermedial understanding of pictorialist portraiture, which he pre-sented in Chicago.

In this same year, Swami Vivekananda gave his famous address to the Chicago Parliament of World Religions and Ravi Varma received a medal of merit at the Columbian Exposition in the ethnographic category. Bhedwar's own photographs were also displayed at the Columbian Exposition, but in the photography section. Incidentally, he was also the only speaker at the Congress of Photographers who was not of European origin. Subsequently, his works were featured in *The American Amateur Photographer*, a journal that Alfred Stieglitz, a man determined to legitimize photography as a medium of artistic expression equivalent to painting and sculpture, edited from 1893 to 1895.[5] This forum may have provided Bhedwar with entrée into America's photography circuits. It may also have facilitated his participation in a number of exhibitions in Philadelphia, New York, and Chicago.

Bhedwar had returned to Mumbai in 1892 and thus his participation in the British photography section of the Columbian Exposition in 1893 is puzzling. His induction

FIGURE 1

Shapoor N. Bhedwar (Indian, 1858–ca. 1920)
The Flower Girl, from the series "Feast of Roses,"
1890
Gelatin silver print
14 5/16 x 10 5/8 inches
National Gallery of Australia, Canberra, acc. no.
NGA 2009.1109

into the Brotherhood of the Linked Ring in 1892, a society established in London in the same year to promote pictorialist aesthetics, is equally intriguing; he was the only non-European member. By the 1900s, the vision of photography presented by the Linked Ring had generated similar organizations in Vienna, Paris, and New York. Stieglitz, who was inducted into the Linked Ring in 1897, initiated the journal *Camera Notes* as a transatlantic platform for the promotion of pictorialism. Subsequently, in 1902, he formed the New York Photo-Secession group with his younger colleague Edward Steichen. Bhedwar, meanwhile, from distant Mumbai, played an active role in the Linked Ring's General Committee, often serving on the exhibition selection committee until the group's dissolution in 1910.

It is likely that Bhedwar's investment in pictorialism lay in the movement's central tenet: while those who identified themselves as pictorialists certainly developed individualistic styles, they shared the assessment that technical proficiency in itself was insufficient as a mark of good photography. Despite their other disagreements, members of the Linked Ring were thus united in their belief that the crux of the matter lay in the portrayal of mood, character, and sentiment. This strong conviction in the aesthetic quality of photography might have appealed to Bhedwar by enabling him to subordinate any delimiting connotations of artisanal skill often associated with non-Western artists in the Western cultural imaginary, while allowing him to transcend colonial conventions of ethnographic portraiture that focused on castes, racial groups, and occupational categories (figure 2).

This utilization of photography in ethnographic mapping is perhaps best exemplified in *The People of India* (1868–75), published by the British Indian Office (figure 3).[6] Projects such as this connected the technology of photography to a bureaucratic epistemology in order to establish a vast photographic archive that was deemed necessary for the proper governance of the colony and its people. With his embrace of pictorialism, Bhedwar may

27

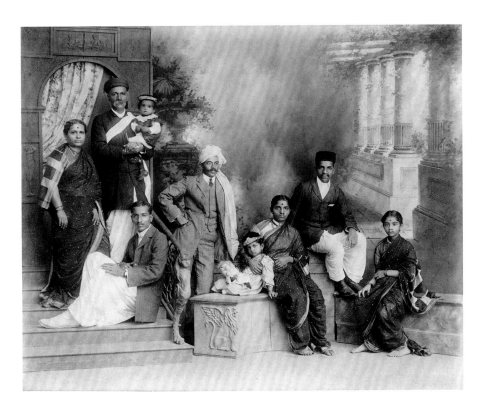

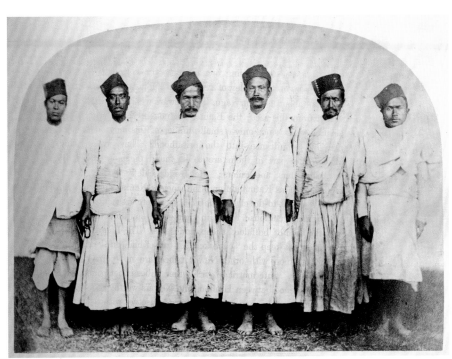

FIGURE 2
Shapoor N. Bhedwar (Indian, 1858–ca. 1920)
Untitled, 1910
Platinum print
9 7/16 x 11 13/16 inches
National Gallery of Australia, Canberra,
acc. no. NGA 2010.7

FIGURE 3
Unknown photographer
*Banras, subdivision of Newars, Nipal [Nepal]
between 1868–1875, from The People of
India: A series of photographic illustrations,
with descriptive letterpress, of the races and
tribes of Hindustan, originally prepared under
the authority of the government of India, and
reproduced by J. Forbes Watson and John
William Kaye between 1868–1875*
Albumen print
5 ¾ x 8 inches (image); 9 ½ x 13 ¼ inches (sheet)
Ames Library of South Asia, University of
Minnesota, Minneapolis

have sought to destabilize this colonizing epistemology of photography. His inclusion of European models to depict Indian themes may have been an attempt to disrupt ethnicity as the sole ontological locus of cultural subjectivity.

Simultaneously, the pictorialist emphasis on the depiction of mood might have allowed Bhedwar to partake in contemporaneous anti-imperial aesthetic discourses in India that re-allocated the evocation of *bhava*, or emotion, as a privileged domain—in opposition to Western art's emphasis on the mimetic representation of reality. However, Bhedwar, who belonged to Mumbai's Westernized Parsi community, did not explicitly align himself with the nationalist movement in India. Nor did he situate his artistic practice within the parameters of indigenous aesthetic theorizations. Instead, he described the portrayal of emotion and sentiment in terms of a universal paradigm rather than in relation to any particular tradition. In regard to portraiture, Bhedwar wrote: "An eminent critic has defined truth in art to be 'the faithful statement either to the mind or the senses of any fact in nature,' or as [Thomas] Carlyle epigrammatically expressed it, as 'the disimprisoned soul of fact.'"[7] His rejection of an ontological distinction between the East and the West was thus categorical.

Vignette Two: Kolkata, ca. 1936

In 1936, the Kolkata-based artist Abanindranath Tagore was completing a handwritten manuscript with montages composed of photographs from contemporaneous newspapers, prints, and advertisements. The manuscript begins innocuously, with the frontispiece declaring that the author has scripted a *jatra*—a vernacular form of theater—based on the Indian epic *Ramayana*. Divided into seven parts, the subsequent textual narrative follows the epic: The hero Rama is exiled from the kingdom of Ayodhya because of the scheming of his stepmother. His beloved wife Sita joins him in the forest but is soon abducted by the demon-king Ravana, dressed in the guise of a monk. Sita, however, leaves a trail of jewelry to enable Rama to track her. In Tagore's work, photographs from a European jeweler's catalogue, overlaid with a British coin, indicate the trail.

Neither the advertisement of the English dairy company nor the invocation of the Kolkata-based British jeweler on the frontispiece of Tagore's manuscript is especially remarkable. Scholars recently have demarcated the modes through which vernacular visual practices in nineteenth- and early twentieth-century South Asia restructured their vocabulary in response to the cultural economies of the British empire.[8] However, finding such an interpolation in Tagore's work is somewhat surprising, especially given that the artist's oeuvre has been situated in art history as marking an exemplary conjunction between aesthetics and anticolonial nationalism.[9] Yet, Tagore's Hanuman, the monkey-god leader of Rama's army, is hardly heroic. In Tagore's iteration, new technologies of travel, signified in the collage by the airplane, dissolve the magicality of epic time (figure 4). The pasted clock further reiterates the dissolution of the magical under the time of colonial modernity. By colluding epic time with the technologically driven modernization that marked the years preceding the Second World War, the artist thus re-created a messianic temporality that drew the past, the present, and the future into the same tense moment.

The intention, certainly, was not to infuse the present with the magicality of the past. Tagore included news photographs of military parades in Moscow's Red Square (figure 5) and the overhaul of Japan's materiel in preparation for territorial expansion. All of these images appear in Tagore's *Lankakanda* section of the *Ramayana*, recasting the primordial struggle between the heroic Rama and the demon Ravana in the here and now of colonial modernity.

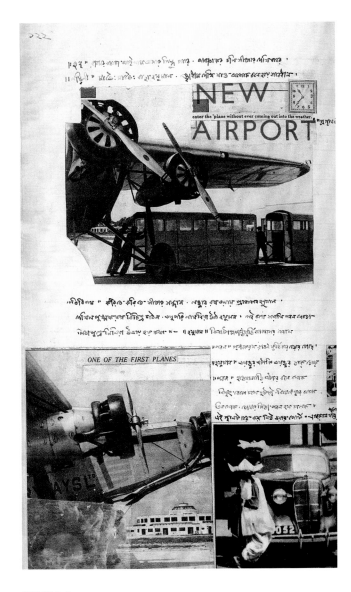

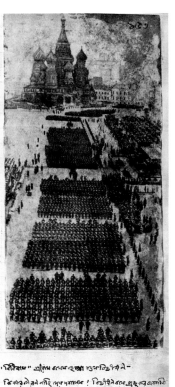

FIGURE 4

Abanindranath Tagore (Indian, 1871–1951)

Hanuman's journey. Khuddur Ramayana,

1934–42

Artist's book

18 x 14 inches

Private collection

Image courtesy of Saranindranath Tagore

FIGURE 5

Abanindranath Tagore (Indian, 1871–1951)

Military parades in Moscow's Red Square.

Khuddur Ramayana, 1934–42

Artist's book

18 x 14 inches

Private collection

Image courtesy of Saranindranath Tagore

In each instance, the original photographs were drawn from British newspaper reports.

From the late nineteenth century onward, the British news service Reuters had gained monopoly as a provider of news and photographs across the empire, thanks largely to a worldwide network of British-owned undersea cables. Vernacular newspapers in the colonies thus routinely subscribed to Reuters even as they vehemently criticized it as empire-centric. If, on the one hand, this news network connected Europe to its colonies, on the other hand, it also connected a vast anti-imperial network that cut across the colonial worlds of Shanghai, Kolkata, and Cairo. The world was distant, yet already very close.

This, indeed, becomes evident in Tagore's *Ramayana* manuscript, where the battle between Rama and Ravana becomes a foil for impending war. One example is a cartoon in the manuscript that depicts an African soldier heading toward Spain and a gas mask–clad European soldier heading toward Abyssinia (figure 6). Tagore's references were the Italian invasion of Abyssinia in 1935 and the Spanish Civil War. Political cartoonist Will Dyson's original drawing, from which Tagore extracted the image, had appeared in the *London Daily Herald* in 1936, as a comment on the complex racial dynamics of the Franco-Mussolini alliance, in particular Franco's Army of Africa from Spanish Morocco and Mussolini's cannibalization of Ethiopia.

References to Abyssinia had appeared in a number of Indian newspapers as well. In the colonial cultural imaginary, the Fascist claim on Abyssinia—an event that indelibly altered the political fabric of Europe—had a very specific resilience. It became conjoined in the Indian intellectual imaginary with European imperialism's encroachment on the sovereignty of people of color, producing a new dynamic of African and Asian solidarity across earlier Indian Ocean networks. The theme of Afro-Asian solidarity would become especially prominent during the decades

FIGURE 6

Abanindranath Tagore (Indian, 1871–1951)

Soldiers. Khuddur Ramayana, 1934–42

Artist's book

18 x 14 inches

Private collection

Image courtesy of Saranindranath Tagore

that followed the conclusion of the Second World War, eventually leading to the formulation of Afro-Asian networks of the Non-Aligned Movement in opposition to the bipolar politics of the Cold War.

But Tagore's reassembly of news photographs and cartoons is significant for other reasons as well. Instantaneously circulated throughout the empire by agencies such as Reuters, these images collated in Tagore's manuscript reveal a symbiosis between nationalism and universalism, mediated through the photograph and the telegraph. In the colony, the telegraph, after all, had become an adjunct of the photograph. Both inhabited "a networked space, a de-territorialized informational matrix, cross-referenced by the mobility of the code," to use Chistopher Pinney's words.[10]

Vignette Three: Mumbai, ca. 1956

In June 1956, *The Family of Man*, a traveling photography exhibition curated by Edward Steichen, the Director of Photography at New York's Museum of Modern Art, opened at the Jehangir Art Gallery in Mumbai (figure 7). In its first iteration, the exhibition consisted of 503 photographs by 273 photographers, a number that would vary slightly in the second version of the exhibition created for Tel Aviv, Athens, and Beirut. Steichen's intention was to present a vision of humanity as a universal ideal, shared by otherwise dissonant cultural, political, and national constituencies. Steichen conceived the exhibition as a mode of underscoring empathy as the only ethical response to the postwar geopolitical landscape, marked by the memory of the Holocaust, Hiroshima, and Pearl Harbor, along with the continued threat of nuclear annihilation.

The medium of the photograph was ideal for this purpose. For the kind of replication that photography made possible allowed Steichen to circulate *The Family of Man* to a number of locations simultaneously, through the use of four identical copies of the images. Thus, even as the exhibition toured various Indian cities between June 1956 and September 1957, other versions were shown in Paris, Brussels, London, Amsterdam, and Rome. The message of universalism was thus made internal to the exhibition's format. By concurrently viewing the same exhibition, audiences in India, France, Belgium, the United Kingdom, the Netherlands, and Italy were made to perform, as it were, the global family of Steichen's conception. Yet, paradoxically, Steichen's representative images of the people of Asia, Africa, and South America were culled from the work of photographers such as Henri Cartier-Bresson, George Rodger, and Werner Bischof, who were recognized as pioneering a new global professional practice.[11] That the curator selected most of the images from the archives of *Life* magazine and the New York branch of Magnum Photos, both located only a few blocks from Steichen's office at The Museum of Modern Art, serves to magnify the project's inherent contradictions.

Significantly, the only Indian photographer included was the cinematographer Satyajit Ray, who contributed a still from his recent film *Pather Panchali*. The same image appeared on the film's poster, designed by Ray (figure 8). Moreover, *Pather Panchali* made its international premiere in the 1955 *Textile and Ornamental Arts of India* exhibition at MoMA—a part of the museum's investment in Cold War cultural diplomacy. Although not so intended by its curator, *The Family of Man* thus metamorphosed into a vehicle of Cold War propaganda through the subtle interventions of the United States Information Service, which facilitated its global circulation.

The exhibition reached India only months after the Bandung Conference in Indonesia, where twenty-nine Asian and African countries had convened under the leadership of India's first prime minister, Jawaharlal Nehru, Indonesia's Sukarno, Egypt's Gamal Abdel Nasser, and

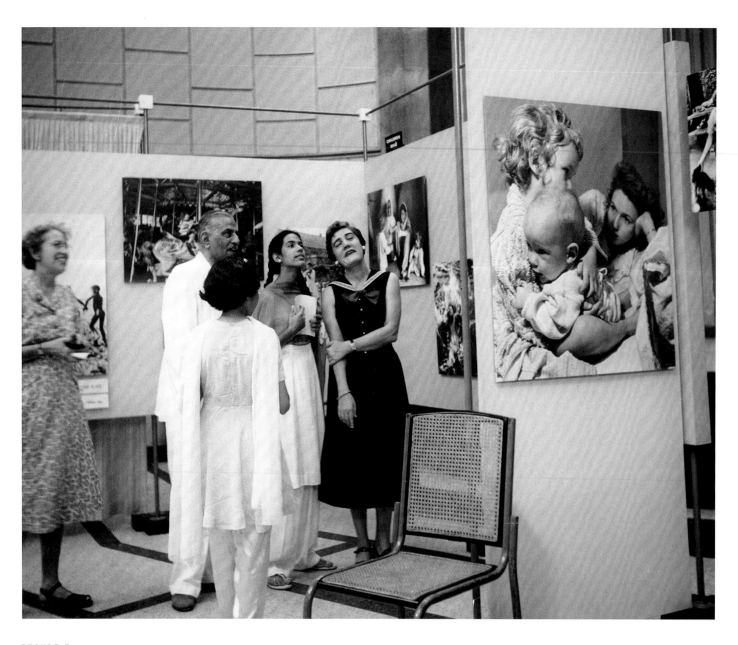

FIGURE 7

Unknown photographer
Visitors at the exhibition The Family of Man
(traveling exhibition organized by The Museum
of Modern Art, New York) at the Jehangir Art
Gallery, Mumbai, on view June 18–July 15, 1956
Documentary photograph © International
Council/International Program Records. "The
Family of Man"; VII.SP-ICE-10-55.6
Image courtesy of the Museum of Modern Art,
New York/Scala, Florence, acc. no. 0147086

Ghana's Kwame Nkrumah to register their opposition to the East-West polarity of the Cold War and the West's cultural imperialism. The Non-Aligned Movement was formalized only in 1961, but as official reports indicate, Nehru's role in Bandung was already viewed by the United States with deep suspicion and there were concerted efforts to court the new nation-state through cultural diplomacy.[12] *The Family of Man* was a part of this effort.

Nonetheless, the exhibition was of critical significance, both within India and internationally. Its scale and scope were unprecedented in the context of photography; it was the largest photo exhibition that Indian audiences would have encountered until then. After its initial appearance in Mumbai, the exhibition traveled to Agra, New Delhi, Ahmedabad, Kolkata, and Madras, concluding its Indian sojourn in Trivandrum in late September 1957. "In India,"

the United States Information Agency reported to the United States government, "monsoon rains did not prevent a quarter of a million people from forming queues outside the exhibition."[13]

Although keenly aware of the increasingly aggressive force of cultural diplomacy, Indian audiences largely ignored the political aspects that made possible the exhibition's presence in India.[14] Instead, they were drawn to the sheer number of works on display, the stylistic aspects of composition, and the depth and richness of the photographic image.[15] The impact was almost immediate. Within three years, the Bombay Photography Association launched a competition: more than one hundred thousand entries were submitted from photographers across India. The winning entries were subsequently displayed in *Images of India*, held in 1960 at the Jehangir Art Gallery in Mumbai where *The Family of Man* had opened in 1956. The title of the exhibition made reference to the late nineteenth-century ethnographic project *The People of India*.

The narrative presented in the exhibition, however, strategically reworked the imperialist lens of colonial photography. Divided into themes such as "birth," "growth," and "work," the exhibition visually invoked the history of the independent nation-state. For instance, while photographs of pre-modern temple sculpture by R. R. Bharadwaj stood for India's hoary past, images of toiling laborers by Pramod Pati signaled the new nation's mission of modernization through the rapid construction of planned cities, hydroelectric projects, and heavy industry. In this sense, *Images of India* differed significantly from *The Family of Man*, even as it drew its inspiration from Edward Steichen's curatorial enterprise. While Steichen had presented a vision of rural India, untouched by modernity, photographs in the Indian exhibition deftly juxtaposed rural harvesting festivals with the modern time of technologically driven industrialization, thus grounding photography in the everyday materiality of India's postcolonial present.

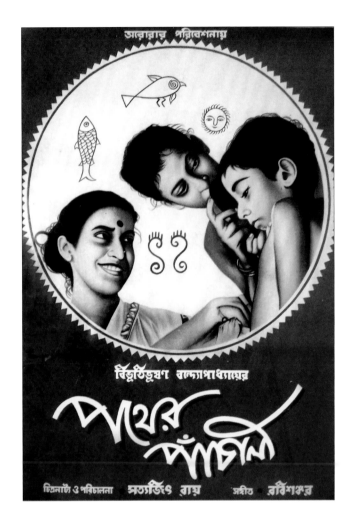

FIGURE 8
Satyajit Ray (Indian, 1921–1992)
Pather Panchali, 1955
Film poster
29 x 20 inches
Ray Family/Satyajit Ray Film and Study Collection,
University of California, Santa Cruz

Simultaneity

This essay began with the question of belatedness. The history of photography in India bypasses the question of belatedness precisely because it points toward both simultaneity and irreducible inter-connectedness. The 1960 *Images of India* exhibition, for instance, rooted as it was in the desires and aspirations of a newly independent nation, remained deeply linked to a global history of photography. The exhibition drew inspiration from Edward Steichen's *The Family of Man*. Steichen's own discourse was fundamentality shaped by the events leading up to the Second World War, the contours of which were delineated in the collages that the Bengali artist Abanindranath Tagore created using news photographs circulated by Reuters in the 1930s. As early as 1936, Tagore registered the first signs of an emergent Afro-Asian solidarity, which would eventually consolidate and gather force under the aegis of the Non-Aligned Movement during the Cold War. The contrapuntal pressure generated by the Non-Aligned Movement, consequently, would serve as the immediate political imperative for *The Family of Man*'s display in India.

This densely interrelated matrix goes deeper. Steichen had closely collaborated with Alfred Stieglitz to secure photography's place as an independent art form in the early twentieth century. The first vignette delineates the relationship that Stieglitz shared with his contemporary Shapoor N. Bhedwar through the elite international society of photographers, the Linked Ring. Steichen may even have been familiar with Bhedwar's work, although it is unlikely that the two ever met.

Without doubt, such global connections were constitutive. The world that photographers such as Stieglitz and Bhedwar shared cannot be easily folded into art history's established teleological frames and center-periphery models. Indeed, the active participation of individuals such as

Bhedwar in the institution of photography as a legitimate domain of artistic practice may have been possible precisely because photography itself was still on the margins of art in Europe and North America.

Nonetheless, it is certain that Indian photographers remained embedded within a transcontinental world that they shared with their contemporaries across the globe. Their experience of this shared world may have been paradigmatically specific and conceptually fractured, indeed multiple and plural. However, the simultaneity that did exist serves to open up the possibility of different configurations of contemporaneity, while repopulating the history of photography with a series of transcultural encounters that have remained external to its conventional narrative registers.

1 Hal Foster, "An Archival Impulse," *October* 110 (2004), 4.

2 Ibid., 22.

3 Ibid.

4 For a biography of Shapoor N. Bhedwar, see "Distinguished Photographers of Today," *The Photographic Times* 24 (1894), 181–85.

5 See *The American Amateur Photographer* 7 (1895).

6 *The People of India: A Series of Photographic Illustrations with Descriptive Letterpress, of the Races and Tribes of Hindustan, ed. by J. Forbes Watson and John William Kaye*, 8 vols. (London: India Museum, 1868–75).

7 Shapoor N. Bhedwar, "Portraiture," *The American Amateur Photographer* 5 (1893), 352, see also 349–58.

8 See, for instance, Natasha Eaton, *Mimesis across Empires: Artworks and Networks in India, 1765–1860* (Durham, North Carolina: Duke University Press, 2013).

9 See Tapati Guha-Thakurta, *The Making of a New Indian Art: Artists, Aesthetics and Nationalism in Bengal,1850–1920* (Cambridge: Cambridge University Press,1995).

10 Christopher Pinney, *The Coming of Photography in India* (London: The British Library, 2008), 79.

11 Eric J. Sandeen, *Picturing an Exhibition: The Family of Man and 1950s America* (Albuquerque: University of New Mexico Press, 1995).

12 Edgar Kaufman, Jr., *Preliminary Report on the Indian Voyage*, 1, Department of Circulating Exhibitions Records, II.1.83.2.1, Museum of Modern Art Archives, New York.

13 *United States Information Agency, 7th Review of Operations* (Washington, DC: US Government Printing Office, 1956), 17.

14 See Mulk Raj Anand, "Photography as an Art Form," *Marg* 14 (1960), 2–3.

15 Selections from the exhibition were reproduced in *Marg* 14 (1960).

LATIKA GUPTA WITH JODI THROCKMORTON

ARTI

STS

NANDAN GHIYA

(born Jaipur, 1980; lives and works in Jaipur)

Nandan Ghiya was born and raised in Jaipur, an erstwhile princely state in Rajasthan in western India, where he now teaches. His parents were art dealers and his earliest memories are of growing up surrounded by pictures of "ancestors, gurus, and political heroes" hanging on the walls of his old ancestral home. Jaipur has been a major arts center from at least the seventeenth century, particulary noted for the miniature painting that was patronized by successive royal courts and continues today in small ateliers across the city, now catering to the souvenir market. The capital of the desert state of Rajasthan for more than four centuries, it also lay at the forefront of indigenous experiments in photography. Sawai Ram Singh, the ruler of Jaipur from 1852 to 1880, was a photography enthusiast; he made numerous self-portraits from an early age. In many of these, he is dressed in ceremonial garb with an elaborate turban; in another example, he wears a suit with a sash and sports a flamboyant moustache; in others, he is posed with props that allude to his learning and royal stature. Sawai Ram Singh also carried out experiments in "trick" photography—using stereoscopic photography and also effects to create a halo around his head. Visitors, members of his court, and the women of the *zenana* were also photographed in elaborate studio arrangements with particularly European pretensions in the poses and props, resulting in images that have often been described as "curious hybrids."[1] By the early twentieth century, photo studios flourished across the city and photography transformed from being the preserve of the elite to a tool for the middle class to create a record for itself. Photo-studio images from the 1930s show subjects posed individually, in pairs, and in large groups against painted backdrops, seated on European-style chairs and on carpets, leaning against cushioning bolsters.[2]

In 2012, Ghiya brought together a melange of images, many of unidentified sitters in photography studios and early painted photographs, to create his own "curious hybrids." In mixing images of completely unrelated sitters, Ghiya created new relationships and familial structures that are akin to interactions and networks that are forged digitally and online, often between strangers, in dating forums, chat rooms, and on social-networking sites.

Painting over and deconstructing photographs of individual men and women posing for photographs, Ghiya drew upon his immediate location in the hyper-digital twenty-first century, both conceptually and visually. He has written about his fascination with the surfeit of imagery: "printed/painted surfaces—walls, hoardings, posters, signs, billboards, shops, malls, vehicles, temples, shrines, etc." He described them as a "huge info-matrix and a jumble of sub-conscious guidelines . . . that are deeply embedded in the mass psyche due to the sheer excess of their existence and high contrast values."[3] For him,

the constant production of visuals, the effect of time on them that leads to unexpected transformations, eventual decay, and cyclical regeneration, turn the world into a living museum that is constantly being modified. A self-professed untrained artist, he described himself as a "vandal"; like time, he works on already existing images, transforming them instantly. However, unlike time that serves to age objects, his interventions make them contemporary, by introducing visuals commonly recognized as computer glitches, corrupted electronic signals, and digital misbehaviors that lead to frozen frames, jagged lines, inverted colors, and pixellation. Instead of incorporating these digital accidents, Ghiya mimics them by painstakingly painting on the surface of the photograph visual interruptions and distortions that extend to the format and frame of the image.

Chairmen and *Female Indroid Album* fuse together more than twenty and fourteen photographs, respectively (plates 1 and 4). The titles offer humorous takes on the subjects. In the former polyptych, each man is photographed seated on a chair, in a posture that exudes authority, real or assumed. A careful look reveals at least three images of women, dressed in saris: two stand beside large chairs, while one is seated. The inclusion of women in a work titled *Chairmen* is itself an interruption in the imagined narrative. Pixels painted over the faces of all the subjects render them anonymous. Similarly, in *Female Indroid Album* (the title a clever play on the words Indian and android), juxtaposed photographs of women ranging from preteen to dotage create an incongruous narrative of Indian women. That these are individuals who were once photographed in formal studio settings on occasions that may have been significant markers in their lives underscores the function of photography as well as its capacity to immortalize bodies long gone.

Download Error, DSC02065 uses as its matrix a popular image from cheap prints of Bhagat Singh, a hero of the Indian Freedom Movement (plate 5). His face is distorted beyond recognition, his head and torso rendered askew in a supposed digital glitch. However, Ghiya has left intact the iconic marker of this figure—Bhagat Singh's hat—thereby signaling the visual saturation that has characterized the twentieth and twenty-first centuries.

Download Error, DSC01720 distorts a late nineteenth-/early twentieth-century portrait of a sumptuously dressed and bejeweled royal man, the face pixellated beyond recognition (plate 2). The stained mount of the photograph and the ornate frame have also been structurally manipulated to transform the physical object of the framed photograph into the visual of a striated digital image, improperly downloaded. Works such as this are emblematic of photography's history: from early studio portraits, painted photographs, and popular prints to the proliferation of image-making in the digital age.

—LG

1 Vikramaditya Prakash, "Between Objectivity and Illusion: Architectural Photography in the Colonial Frame," http://apps.acsa-arch.org/resources/proceedings/uploads/streamfile.aspx?path=ACSA.Intl.1999&name=ACSA.Intl.1999.55.pdf.

2 For images, see http://www.tasveerjournal.com/jaipur-series/.

3 Art Bull India, *Emerging Contemporary and the Masters* (auction catalogue), November 5, 2011.

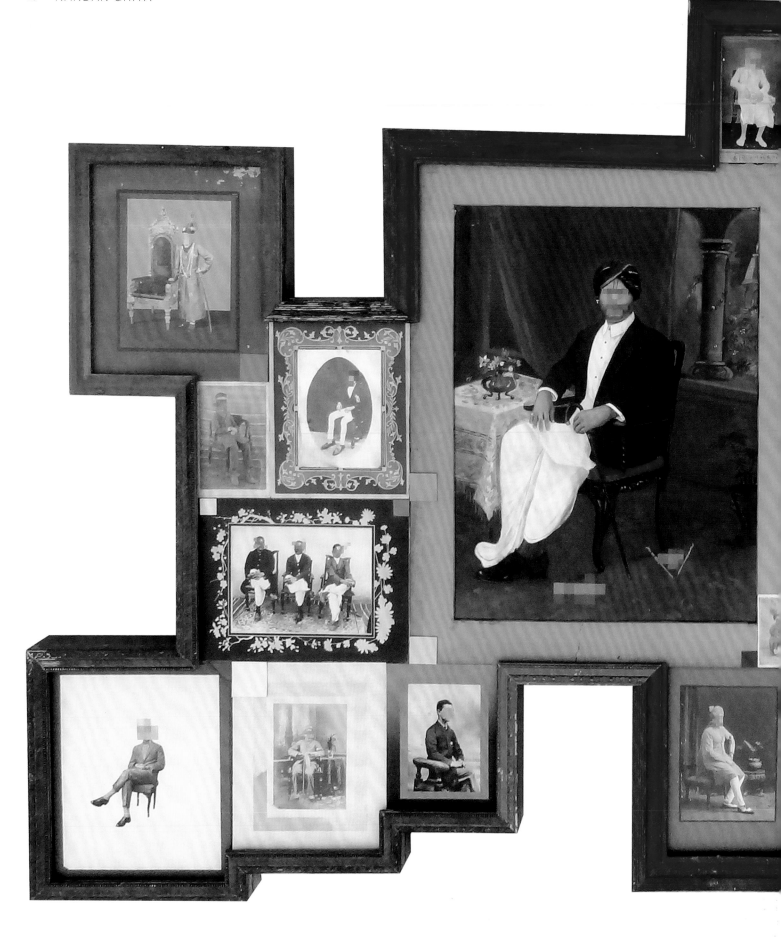

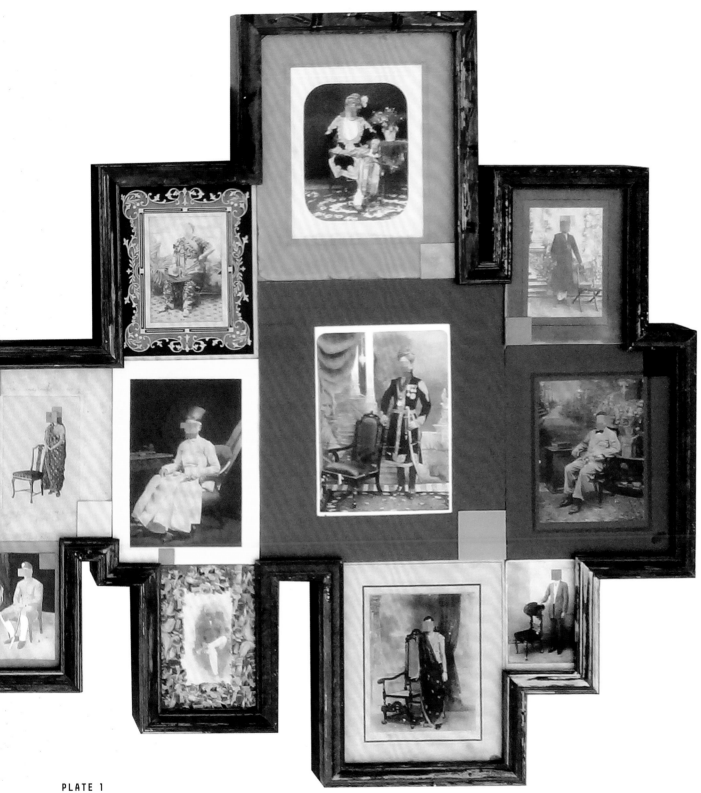

PLATE 1

Chairmen, 2012–14

Photographs, acrylic, laminates, and wooden
frames

49 x 88 inches

Courtesy of the artist and Exhibit 320, New Delhi

Photograph Ranjita C. Menezes

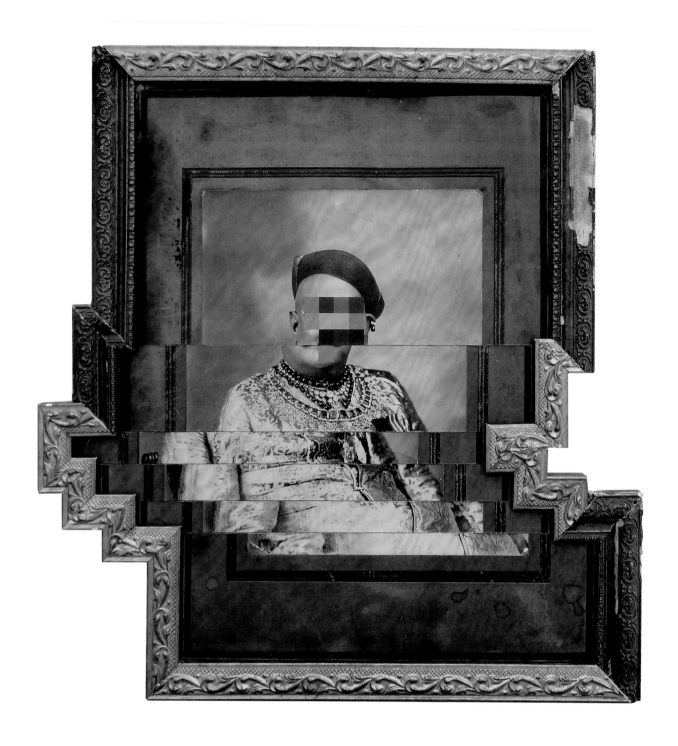

PLATE 2

Download Error, DSC01720, 2012
Photographs, acrylic, and wooden frames
20 ¹⁄₁₆ x 20 ¹⁄₁₆ inches
Courtesy of the artist and Exhibit 320, New Delhi
Photograph Ranjita C. Menezes

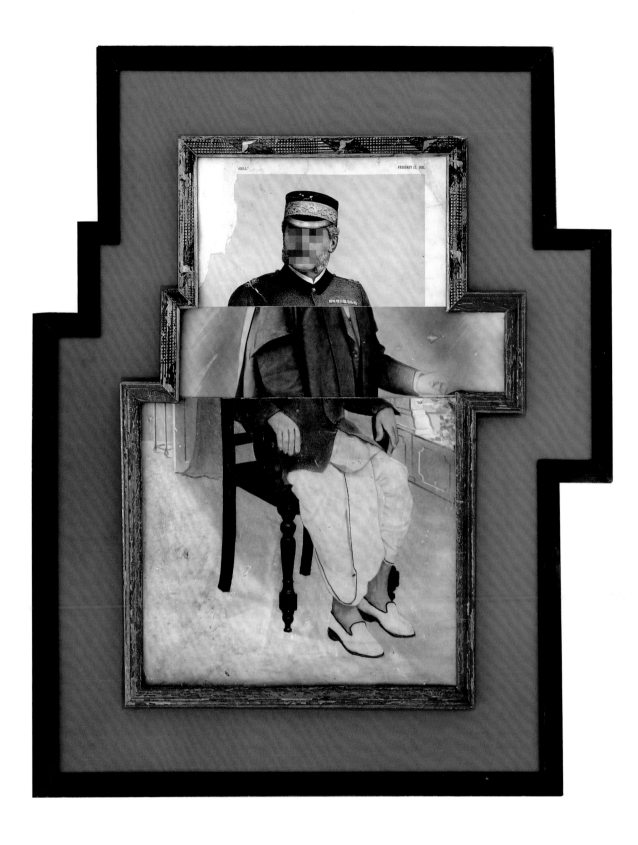

PLATE 3

Varna Sankara V.1.2, 2012

Photographs, acrylic, and wooden frames

31 x 25 inches

Courtesy of the artist and Exhibit 320, New Delhi

Photograph Ranjita C. Menezes

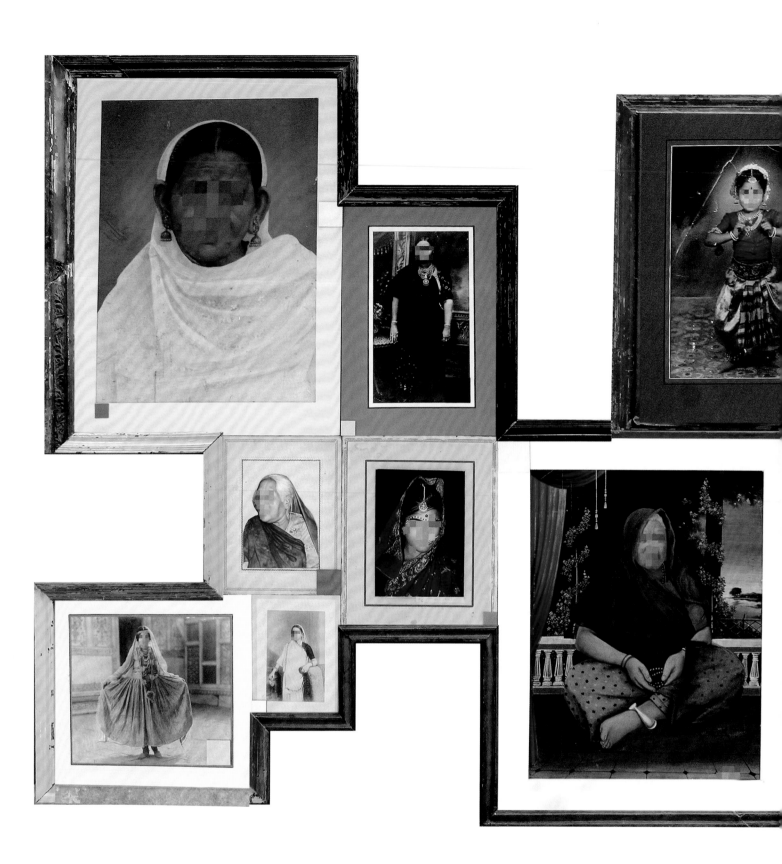

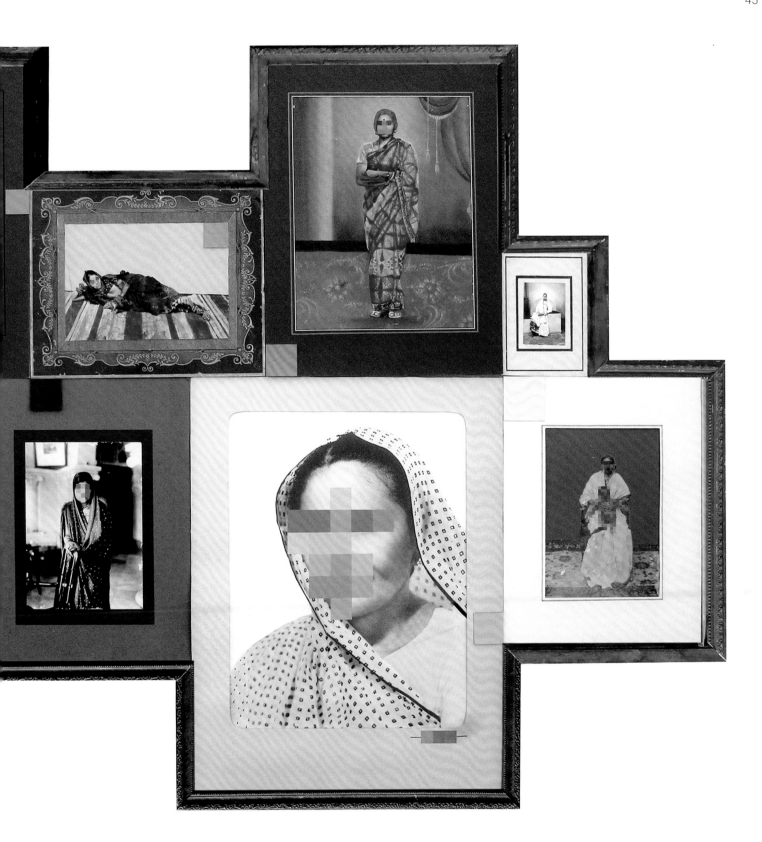

PLATE 4

Female Indroid Album, 2012

Photographs, acrylic, and wooden frames

Two panels, left 48 x 49 ⅝ inches; right 47 ⅝ x 61 inches

Courtesy of the artist and Exhibit 320, New Delhi

Photograph Ranjita C. Menezes

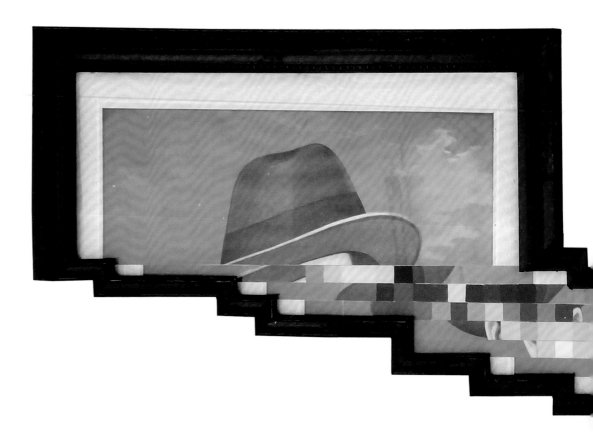

PLATE 5

Download Error, DSC02065, 2012

Photographs, acrylic, and wooden frames

21 ½ x 26 ½ inches

Courtesy of the artist and Exhibit 320, New Delhi

Photograph Ranjita C. Menezes

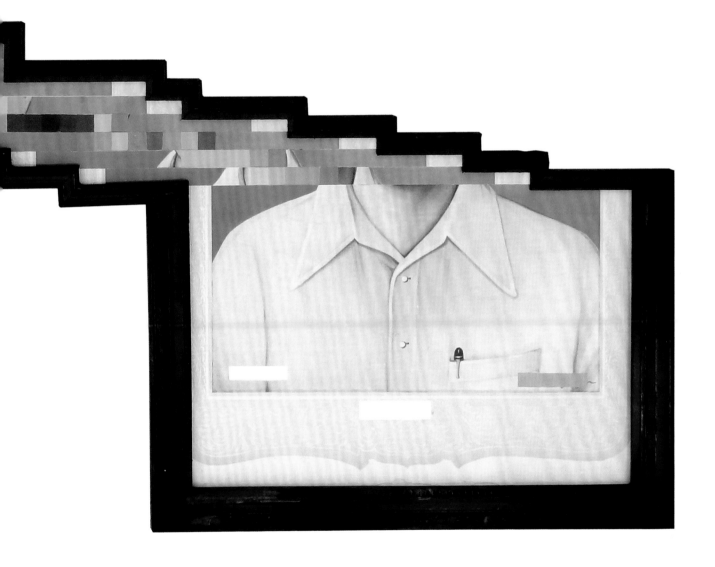

GAURI GILL

(born Chandigarh, 1970; lives and works in New Delhi)

It's so much better if people can choose to be photographed exactly the way they want others to see them. It's their own choice. —Sita[1]

For more than ten years, Gauri Gill has photographed within the communities of Bishnoi peasants, Jogi nomads, and Muslim migrants living in the arid climate of western Rajasthan in India. Gill took more than forty thousand images[2] in Rajasthan for her "Notes from the Desert" series, living for months with the people whom she photographed, often in their homes, and forming enduring friendships (plates 1–3). This vast archive contains both the meaningful and mundane moments in the lives of these impoverished communities—birth, death, destruction, family, friendship, and play—all made more striking against the harsh light and climate of the desert. With this significant body of work and Gill's devotion to and desire to know the people she photographs, she is pioneering a new approach to the long tradition of documentary photography in India—one that is more socially minded than informational.

British colonial photographers in nineteenth-century India set out to capture the exotic and thus emphasized the otherness of their subjects. They searched for what was different from their home country and, in many cases, what in their minds made the people whom they were ruling more primitive. Romantic views of temples and palaces were sent back to Britain alongside ethnographic images of the people of India. The camera was used as a tool to tantalize, document, and control. In "Notes from the Desert," Gill disrupted this essentialist approach to photography (which persists today in travel advertisements that show glamorous women walking the desert in colorful saris and jewels) by treating each subject as an individual and emphasizing moments of shared humanity. In one of her most charming works from the series, *Jannat, Barmer,* Gill photographed a young woman, Jannat, crouched on the ground and gazing intently into a mirror pressed close to her face (plate 1). Jannat, whom Gill knew from the age of fifteen to her untimely death at twenty-three, stares intently at herself as her breath, evidence of life itself, fogs the mirror. The image preserves a rare moment of self-discovery and fleeting girlhood amid the extremes of a desert existence.

For her series "Balika Mela," Gill set up a temporary photography studio at a rural fair for young girls in Lunkaransar, a village in northern Rajasthan (plates 4–13). Her first experience at the fair came in 2003 at the invitation of Urmul Setu Sansthan, a service organization that supports village life in India, including a study camp for girls between the ages of twelve and twenty. At the Balika Mela (fair for girls) in her tent studio, Gill helped the girls

create their own portraits with minimal props and backgrounds. She assumed the role of the itinerant portrait photographer or *photo wallah*—a person who historically has traveled to fairs and villages throughout India offering family portraits and identification images. However, as an activist of the twenty-first century, Gill riffed on this tradition by allowing the girls to determine the way they would be portrayed. As the fair progressed, the girls began to bring personal items—hats made of newspaper, necklaces, their best clothes—or even chose to be photographed with Gill's cameras or tripods. The majority opted to look directly at the camera and be photographed full-length—perhaps in response to earlier studio portraiture in India where clients would insist on paying less for photographs that captured half of their body or only their face. However, the presence of cameras, plastic chairs, and shiny watches underscores the imprint of modern life.

When Gill returned to the fair in 2010, she decided to make color photographs of the young women. She frequently shoots, in Rajasthan especially, with black-and-white film in order to distinguish her photographs from the numerous colorful and romanticized popular images of India. For Gill, the color portraits of the young women are about their personal fashion sense—for example, the combination of a Western windbreaker with the traditional *salwar kameez*. For these portraits, the girls were allowed to experiment, to look at themselves with a camera around their neck, on a motorcycle, or wearing their best clothes. Gill chose to print many of these images on glass negatives, another connection to mid-nineteenth-century methods (plate 4). By inviting the girls to compose their own portraits, however, she empowered, rather than controlled, the young women.

Such empowerment is one of Gill's concerns. Photography offered a way. She began to conduct workshops, encouraging the girls to take photos and to discuss the meaning of photography. The impact on their lives was evident. Maghi, one of the young women who worked with Gill, stated:

Whenever I used to see someone taking photos at a wedding, I would think, how does this work? And I would think, if only I, too, knew how to take photos! But at one point, I thought, no, only people who work in studios can know how, and only boys can know and learn about photos. I'm a girl, so I can't learn. After I came here, I thought that if Gauri "didi" is a girl, and she has come from Delhi and is giving us training, then we can do it too. Since then, the fear of being a girl has left my mind, and I went to the village and took photos.[3]

—JT

1 "Sita," quoted in Gauri Gill, *Balika Mela: Gauri Gill* (Zurich: Edition Patrick Frey, 2012), 155.

2 Kenneth J. Foster, Betti-Sue Hertz, Zehra Jumabhoy, Parul Dave Mukherji, and Nancy Adajania, *The Matter Within: New Contemporary Art of India* (San Francisco: Yerba Buena Center for the Arts, 2012), 62.

3 "Maghi," quoted in Gill, 155.

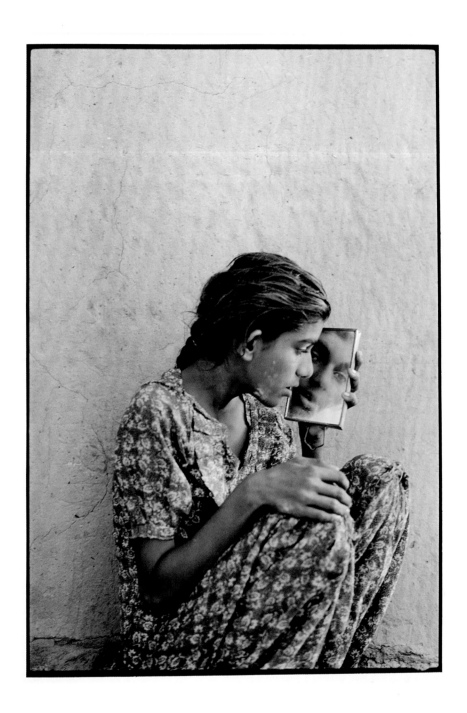

PLATE 1

Jannat, Barmer, from the series "Notes from the Desert," 1999–2010
Gelatin silver print
30 x 24 inches
Collection of the San Jose Museum of Art. Gift of Wanda Kownacki, the Lipman Family Foundation, and Dipti and Rakesh Mathur. 2013.01.01

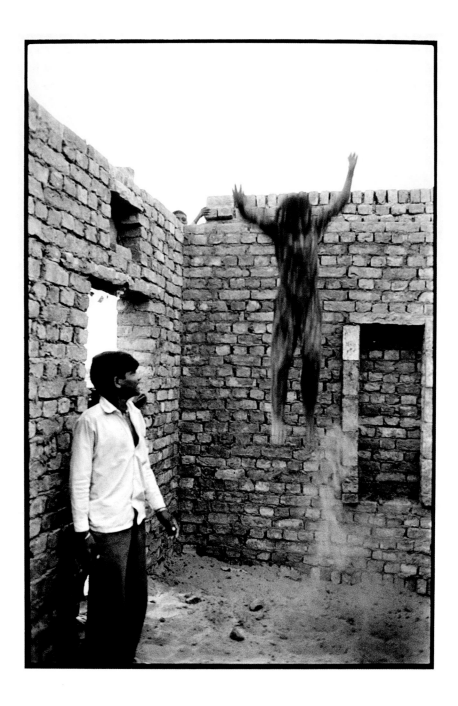

PLATE 2

New homes after the flood, Lunkaransar, from
the series "Notes from the Desert," 1999–2010
Gelatin silver print
30 x 24 inches
Collection of the San Jose Museum of Art. Gift of
Wanda Kownacki, the Lipman Family Foundation,
and Dipti and Rakesh Mathur. 2013.01.02

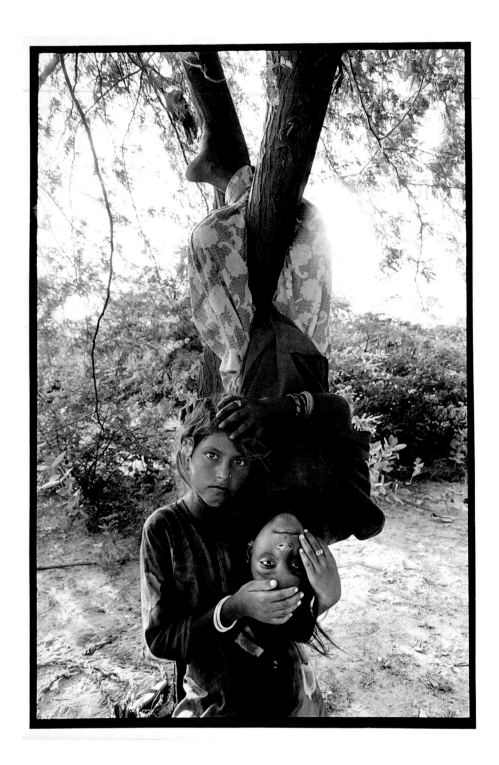

PLATE 3

Urma and Nimli, Lunkaransar, from the series
"Notes from the Desert," 1999–2010
Gelatin silver print
41⁷⁄₈ x 31 inches
Collection of the San Jose Museum of Art. Gift of
Wanda Kownacki, the Lipman Family Foundation,
and Dipti and Rakesh Mathur. 2013.01.03

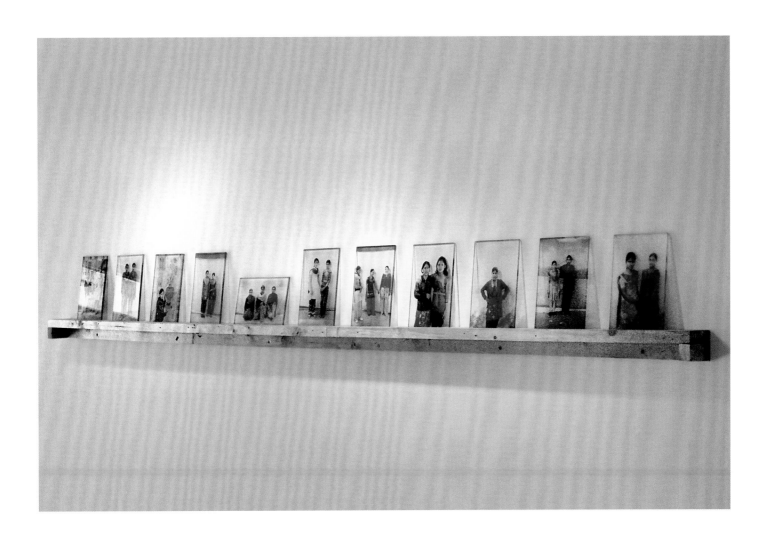

PLATE 4
Installation view of prints on glass from the
series "Balika Mela," 2003/10
Nature Morte, New Delhi, September 15–29,
2012
Image courtesy of the artist

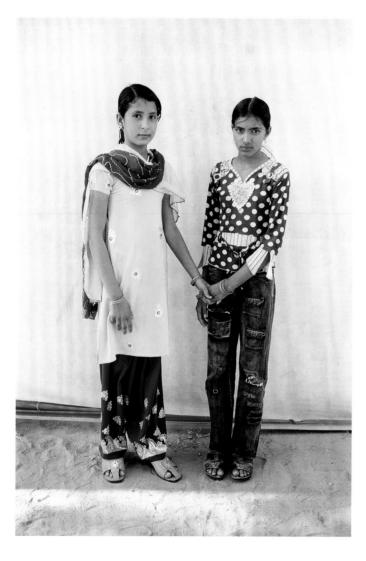 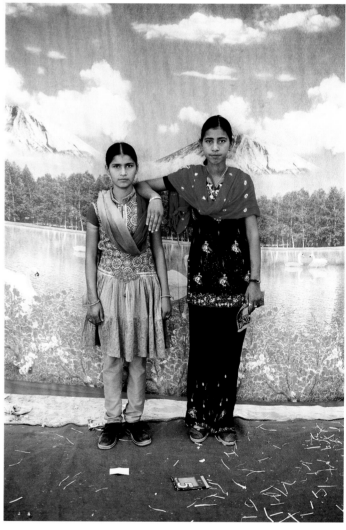

PLATE 5

Fatima and Hathma, 2010, from the series
"Balika Mela," 2003/10
Digital print on glass
10 x 6 ½ inches
Courtesy of the artist

PLATE 6

Indira and Murali, 2010, from the series
"Balika Mela," 2003/10
Digital print on glass
10 x 6 ½ inches
Courtesy of the artist

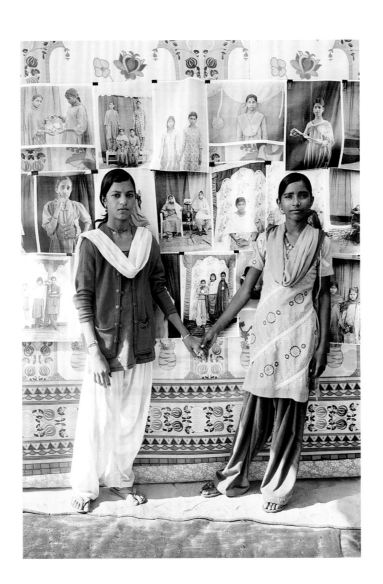

PLATE 7
Manju and Parvati, 2010, from the series
"Balika Mela," 2003/10
Digital print on glass
10 x 6 ½ inches
Courtesy of the artist

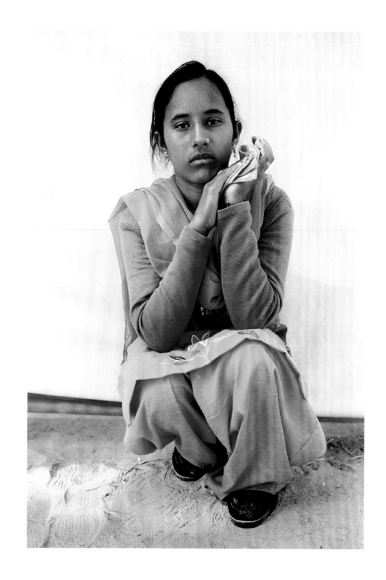

PLATE 8
Maya, 2010, from the series "Balika Mela,"
2003/10
Digital print on glass
10 x 6 ½ inches
Courtesy of the artist

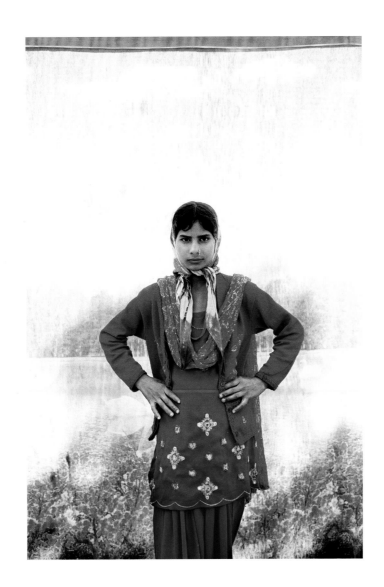

PLATE 9
Suman, 2010, from the series "Balika Mela,"
2003/10
Digital print on glass
10 x 6 ½ inches
Courtesy of the artist

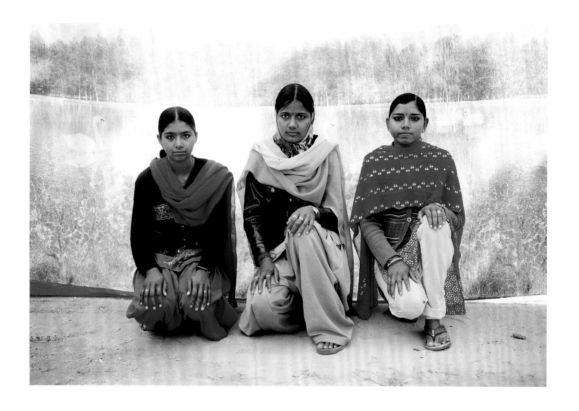

PLATE 10

Salochna, Tara, and Renu, 2010, from the series
"Balika Mela," 2003/10
Digital print on glass
6 ½ x 10 inches
Courtesy of the artist

PLATE 11

Installation view of large-scale prints on
transparent paper from the series "Balika Mela,"
2003/10
Nature Morte, New Delhi, September 15–29,
2012
Image courtesy of the artist

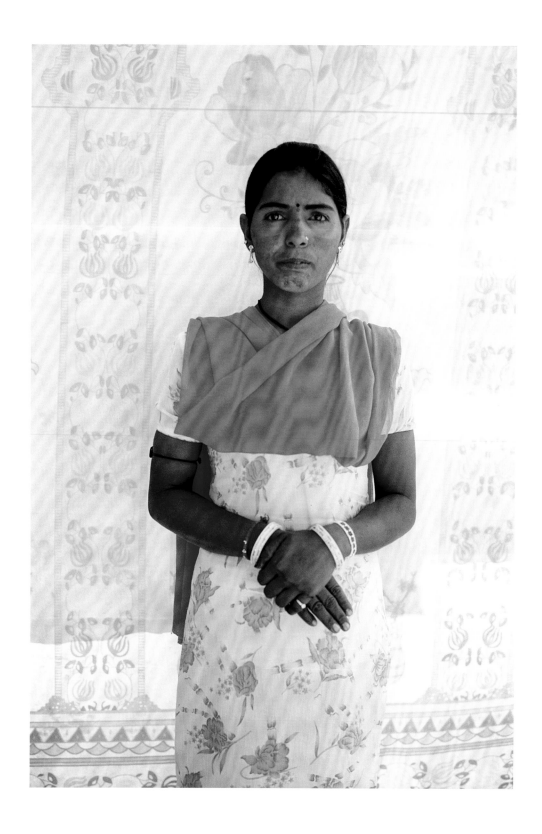

PLATE 12
Nirmala, 2010, from the series "Balika Mela,"
2003/10
Digital print on transparent paper
40 x 27 inches
Courtesy of the artist

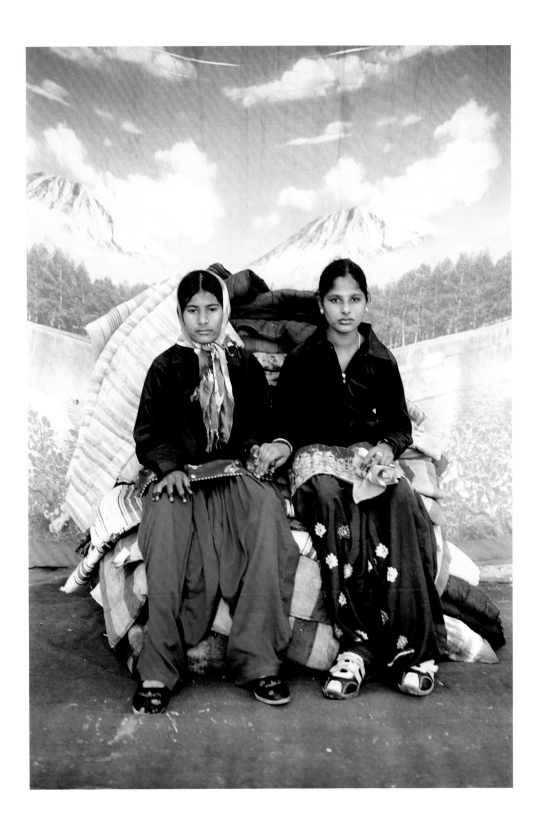

PLATE 13

Parveena and Kaushalya, 2010, from the series
"Balika Mela," 2003/10

Digital print on transparent paper

40 x 27 inches

Courtesy of the artist

JITISH KALLAT

(born Mumbai, 1974; lives and works in Mumbai)

Jitish Kallat graduated from Mumbai's Sir J. J. School of Art in 1996. Established in 1857, the school counts among its illustrious alumni the leading modernists in India. Following in this tradition, Kallat's earliest works were figurative paintings that engaged with the complexities of the port city of Mumbai, one of India's most densely populated metropolises. Kallat made billboard-sized paintings that referenced the massive movie posters that dot the skyline of the city, which is home to Bollywood, one of the largest commercial film industries in the world. However, instead of popular movie icons, Kallat painted portraits of street children and the detritus of a historic city rapidly transforming during the period of India's liberalization. Kallat described how his practice was deeply affected by the economic and socio-cultural changes that began sweeping across urban India in the mid-1990s.

My first year in art school was also the moment of India's liberalization; the tentative embrace of the global and the rapid acculturation that followed were ironically paralleled by a simultaneous ascent of religious fundamentalism and the birth of a new right-wing "rioting" politics It was only in retrospect . . . that I felt how this peculiar moment—when India was trying to reach out to the world and ventilate itself culturally, only to be simultaneously held hostage by its politically stirred-up volatile past—was central to my thinking about art. The international came flooding into one's living room. . . beaming breaking news and music videos, plugging urban India into the reservoir of global culture. A universal lexicon of image and ideas began to unsettle the established glossary of national signs, disturbing identity stereotypes, and injecting a potpourri of new ideas, desires, tastes and mannerisms.[1]

Kallat's visual vocabulary is rooted in Mumbai's busy streets and dense neighborhoods. His images are as much about daily interactions, conversations, activities, struggles, and celebrations of the city's inhabitants as they are about the vertical and horizontal sprawl of its built environment. Kallat described the streets as his "university [in which] one finds all the themes of life and art. . . played out here in full volume. Scale is merely one of the many tools one can deploy in the creation of meaning, and decisions such as big, small, lifesize, etc., are as much acts of meaning creation as they may be retinal or aesthetic considerations."[2]

Building quite literally on this observation, *Artist Making Local Call* is a 360-degree panoramic photograph that depicts a street in Mumbai (plate 1). Made in 2005, using time lag, the image incorporates multiple time frames of the same location. The horizon is composed of the architectural anomalies that define Mumbai's real estate development: high rises, clusters of old houses, commercial establishments—even improvised shelters

that function as both housing and shops. Black and yellow, three-wheeled auto-rickshaws, ubiquitous symbols of public transport in most Indian cities, wait in line for passengers. The technique of time lag results in the virtual collision of a Fiat taxi (typical of Mumbai) with an auto-rickshaw in the background toward the left of the image; the overlapping of time held between red parentheses. The passerbys who appear to walk obliviously past a sight that is likely to be fairly common on these busy streets are actually the same man, photographed in time lag, walking past the moment.

At the center of the image is Kallat, the artist, making a local call at a yellow phone box at the corner of a cluster of repair shops for footwear and electronics, and a small kiosk selling tobacco and cigarettes. A hand-painted sign announces that this is a PCO (Public Call Office). The photograph is emblematic of the city of Mumbai, which Kallat described as a "theatre where the codes of daily existence are pushed to the extreme and this continually percolates my practice."[3]

The photograph was exhibited as part of an evolving large-scale installation at the Dr. Bhau Daji Lad Museum for five months beginning in April 2011. Established in 1872, the erstwhile Victoria and Albert Museum underwent a major restoration in 2008. Best described as a museum of the city of Mumbai, it contains maps, small dioramas, models of different communities who have lived in and built the city, as well as a miscellany of objects that were a part of the patron's family collection. Kallat made interventions in the interior spaces of the museum in an exhibition titled *Fieldnotes: Tomorrow was here Yesterday.* He erected a massive installation of bamboo scaffolding and incorporated sculptural forms appropriated from the façade of the historic Victoria Terminus building in the heart of Mumbai. This major train station is the portal through which more than two million people enter the city daily to eke out a living. The installation, other objects, and the panoramic photograph effectively brought the streets of Mumbai and the people who build them, walk them, and live on them into an edifice that historically was closely associated with the development of art and design education in the city.

Artist Making Local Call, as well as his more recent piece *Event Horizon (the hour of the day of the month of the season)* (plate 2), contain some of the hallmarks of Kallat's conceptual and formal style. The pieces are rooted in his practice that derives from and celebrates the quotidian. In collapsing time and space into a single frozen image, Kallat effects a contemporary mythmaking that mimics the nature of a city physically transforming at a dizzying pace, allowing us a glimpse into multiple temporal planes all at once. These two works both also allude to one of Kallat's earliest conceptual concerns: the relationship of a megacity in India with history, tradition, and global cultures in the twenty-first century.
—LG

1 http://www.summeracademy.at/media/pdf/pdf795.pdf.

2 Jitish Kallat, Interviewed by Rajesh Punj, *The Asian Art Newspaper*, February 2010.

3 *Made by Indians* (Paris: Galerie Enrico Navarra, 2006), 262.

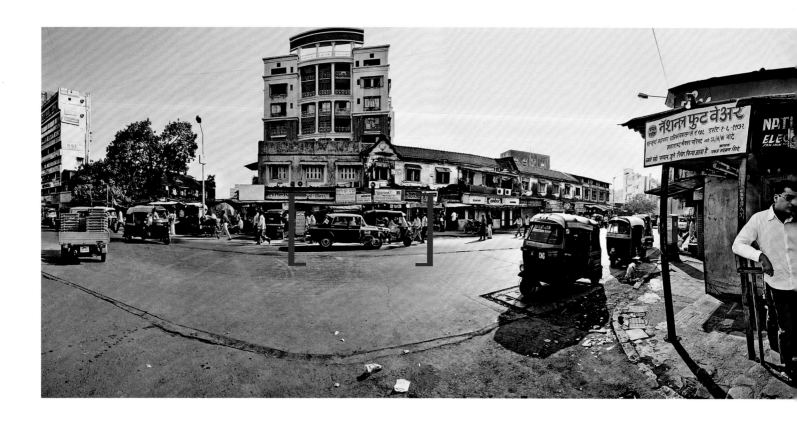

PLATE 1

Artist Making Local Call, 2005

Digital photographic print

95 x 411 inches

Courtesy of the artist

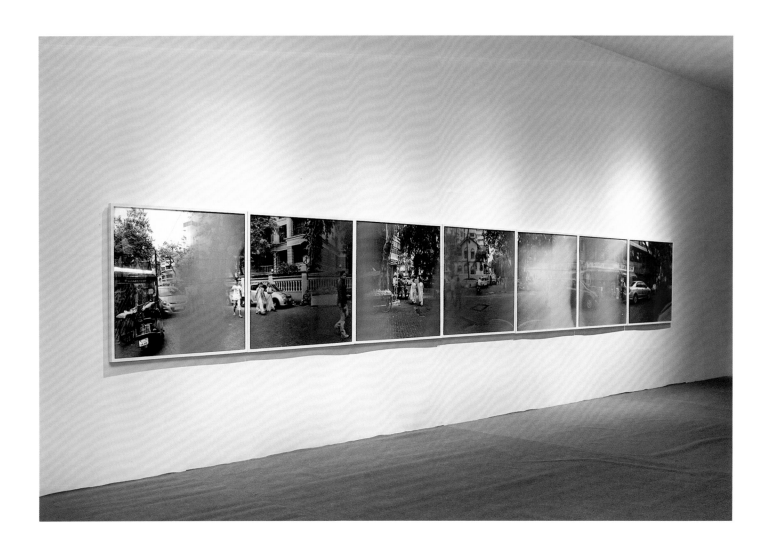

PLATE 2

Event Horizon (the hour of the day of the month of the season), 2014
Lenticular photographic print
Seven parts, 45 x 45 inches each;
45 x 315 inches overall
Courtesy of the artist

PLATE 3

Event Horizon (the hour of the day of the month of the season), 2014 (detail)
Lenticular photographic print
Seven parts, 45 x 45 inches each;
45 x 315 inches overall
Courtesy of the artist

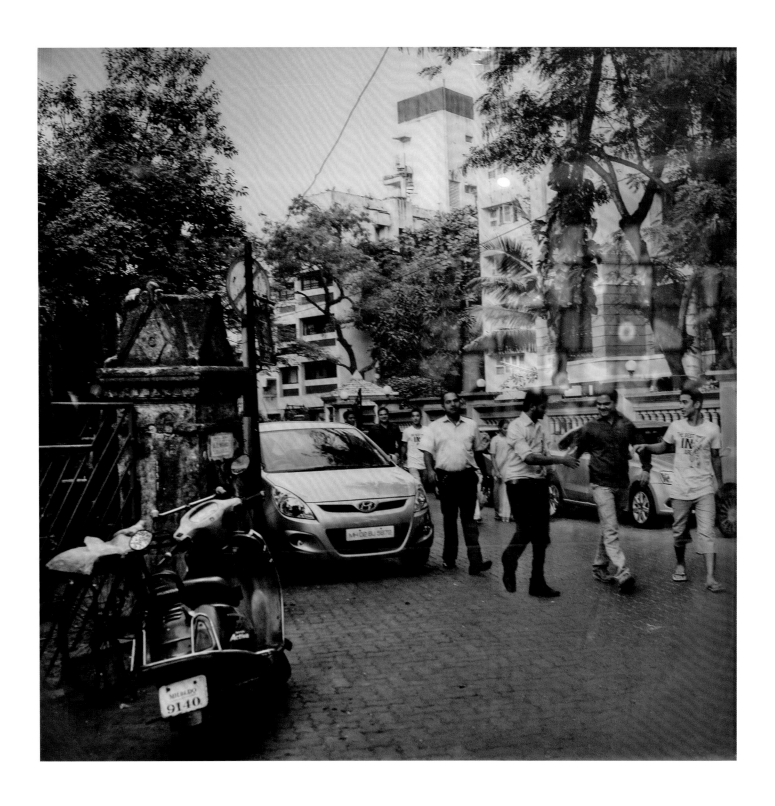

PLATE 4

*Event Horizon (the hour of the day of the month
of the season)*, 2014 (detail)
Lenticular photographic print
Seven parts, 45 x 45 inches each;
45 x 315 inches overall
Courtesy of the artist

PLATE 7

*Event Horizon (the hour of the day of the month
of the season)*, 2014 (detail)
Lenticular photographic print
Seven parts, 45 x 45 inches each;
45 x 315 inches overall
Courtesy of the artist

PLATE 8

*Event Horizon (the hour of the day of the month
of the season)*, 2014 (detail)
Lenticular photographic print
Seven parts, 45 x 45 inches each;
45 x 315 inches overall
Courtesy of the artist

PLATE 9

*Event Horizon (the hour of the day of the month
of the season)*, 2014 (detail)
Lenticular photographic print
Seven parts, 45 x 45 inches each;
45 x 315 inches overall
Courtesy of the artist

ANNU PALAKUNNATHU MATTHEW

(born Stourport-on-Severn, England, 1964; lives and works in Providence, Rhode Island)

Photography was an integral part of the colonial state's project to document and classify different ethnic "types" in India. *The People of India* was published in 1875: eight volumes with almost five hundred albumen print copy photographs of Indian subjects, pasted with detailed descriptions. The sitters posed for formal portraits, individually and in groups with objects of their purported trade or caste (which sometimes determined occupation). The pictures were taken in a studio, often against grids and measuring rulers, thus stripping the subjects of any context. The sitter represented a type—a specimen of a particular caste, community, or occupation. Albums such as *The People of India* and William Johnson's two-volume *The Oriental Races and Tribes, Residents and Visitors of Bombay* (1863–66) exemplify the link that James Ferguson drew between the "archaeological and ethnographical record."[1] Moreover, as John Falconer wrote, "Whether in the service of the rising science of ethnology, or as the creation of 'exotic' souvenirs of the East, photography of racial types became, alongside architectural photography, the most important of the 'officially' sponsored uses of the medium."[2]

Photography's ethnographic function likewise underlaid J. P. Morgan's commissioning of a mammoth project to document the North American Indian: more than fifteen hundred photographs taken by Edward S. Curtis and published in twenty volumes between 1907 and 1930. *The*

North American Indian—Being a series of volumes picturing and describing The Indians of the United States and Alaska was edited by an anthropologist, F. W. Hodge, and combined narrative text with photogravure images.

In 2001, Annu Palakunnathu Matthew created a series of performative portraits that drew upon these ethnographic photography albums. "An Indian from India" emerged from the question that Matthew was often asked as an immigrant in North America: "Where are you from?" This deceptively simple inquiry seeks to establish the identity of an individual through links to a particular land, community, language, and set of beliefs. The question itself arises when someone looks "different," or like an "other," perhaps not from the place the person is presently located. The "where" that frames the question seeks to situate the other and establish an intrinsic relationship between person and place—meaning not just geography but the political and cultural histories from which identity begins to be defined. Matthew was born in England, raised in India, and now lives and teaches in the United States. "An Indian from India" plays with this crisscrossing of identities and the similarities that underlie processes of "othering." Matthew explained, "When I say that I am Indian, I often have to clarify that I am an Indian from India. Not an American-Indian, but rather an Indian-American, South-Asian Indian or even an Indian-Indian. It seems strange that all this confusion started because Christopher

Columbus thought he had found India and called the native people of America collectively as Indians."[3]

Matthew paired photographs of Indians—a Native American from the nineteenth century and one of herself, "an Indian from India," in which she mimicked the studio backdrop, make-up, posture, gestures, and tonalities of the earlier image (plates 1–10). Her intention was to "challenge the viewers' assumptions of then and now, us and them, exotic and local."[4] The juxtapositions effectively question not only assumptions about the self and the other, but also what constitutes a recognizable image of India itself: How is "Indiannness" constructed and recognized? Can it be thought of as a homogenous category? Matthew dressed in typical "Indian" textiles and jewelry from across the country. She played on the titles of the American Indian photographs, for example, *Feather/Dot* features a man with a feather in his hair paired with an image of Matthew seen with a *bindi*, a symbolic forehead ornamentation traditionally made of vermillion pigment, worn by women in many regions across South Asia (plate 5). Two sets of images starkly highlight the "civilizing" mission that Matthew maintains continues today: *Quanah & Annu (Indian)* depicts Matthew and Quanah Parker wearing indigenous clothes and ornaments (plate 1). This is complemented by a pairing of a photograph of Parker, now neatly dressed in a suit, tie, and hat with a photograph of Matthew similarly attired in plain black (plate 2). The smoothing out of differences and a growing homogeneity may have been part of the colonial enterprise, but today they are a hallmark of globalization.

Matthew utilizes technology to play with notions of history and remembrance. She admits that with her formative years being spent in England, her own memories of India are those of an outsider. She refers to India as her "cultural homeland." In *Open Wound "1947"—Encyclopedia*, she excavated family albums to cull images of three generations of women and presented archival and recent photographs together in a video that collapses time

and space (plate 11). It disrupts the construction of memory based on history's linear division into past, present, and future. *Open Wound "1947"—Encyclopedia* continues Matthew's exploration of "ideas about time and the warping of cultures over time. I collapse the presumed progression of time, so the past and present, Indian and Western, appear in the same virtual space."[5]
—LG

1 John Falconer, *Pioneers of Indian Photography, India: Pioneering Photographer—1850–1900* (London: The British Library and The Howard and Jane Ricketts Collection, 2001), 22.

2 Ibid.

3 http://www.annumatthew.com/artist%20statement/Indian_statement.html.

4 http://www.tasveerarts.com/photographers/annu-palakunnathu-matthew/artists-statement/.

5 Annu P. Matthew, interviewed by Dr. Andrew Cohen, 2009, http://www.tasveerarts.com/photographers/annu-palakunnathu-matthew/interviews/ .

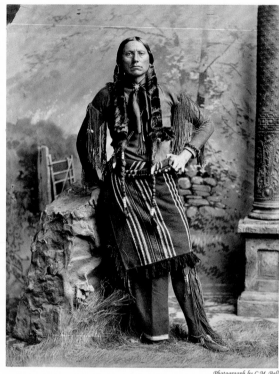

Photograaph by C.M. Bell

QUANAH PARKER, WASHINGTON D.C., 1880s

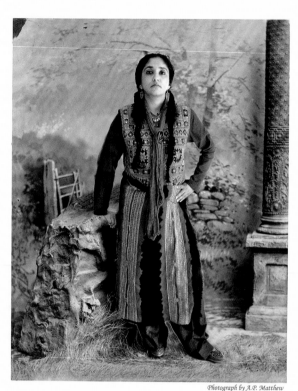

Photograph by A.P. Matthew

ANNU PALAKUNNATHU MATTHEW, PROVIDENCE R.I., 2000s

PLATE 1

Quanah & Annu (Indian), from the series "An
Indian from India—Portfolio II," 2001
Archival pigment print
12 x 16 inches
Courtesy of the artist and sepia EYE, New York

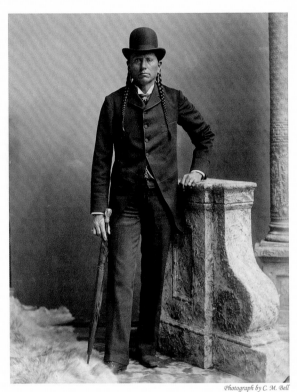

QUANAH PARKER, WASHINGTON D.C., 1880s

Photograph by C. M. Bell

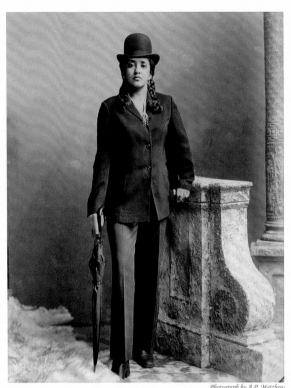

ANNU PALAKUNNATHU MATTHEW, PROVIDENCE, R.I., 2000s

Photograph by A.P. Matthew

PLATE 2

After Parker, from the series "An Indian from
India—Portfolio II," 2001
Archival pigment print
12 x 16 inches
Courtesy of the artist and sepia EYE, New York

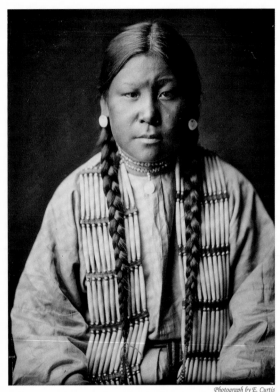

AMERICAN INDIAN WITH BRAIDS

Photograph by E. Curtis

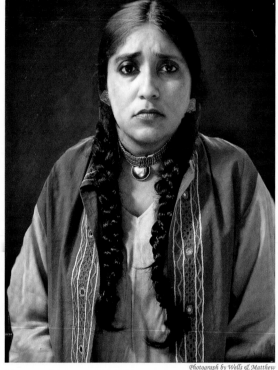

INDIAN AMERICAN WITH PLAITS

Photograph by Wells & Matthew

PLATE 3

American Indian with Braids, from the series
"An Indian from India—Portfolio II," 2001
Archival pigment print
12 x 16 inches
Courtesy of the artist and sepia EYE, New York

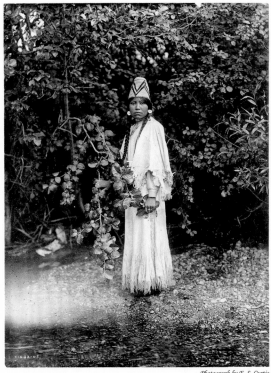

A FAIR MAIDEN

Photograph by E. S. Curtis

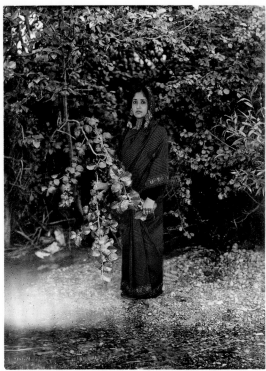

A DARK MAIDEN

Photograph by Wells, Wells & Matthew

PLATE 4

Fairdark, from the series "An Indian from India—
Portfolio II," 2001
Archival pigment print
12 x 16 inches
Courtesy of the artist and sepia EYE, New York

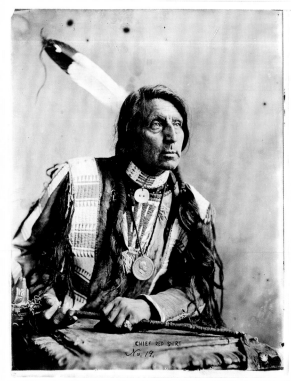

FEATHER INDIAN

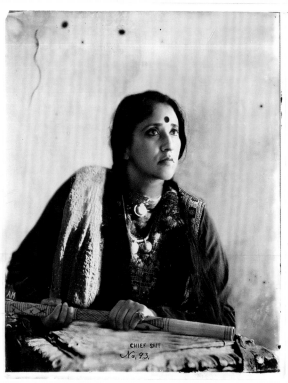

DOT INDIAN

PLATE 5

Feather/Dot, from the series "An Indian from
India—Portfolio II," 2001
Archival pigment print
12 x 16 inches
Courtesy of the artist and sepia EYE, New York

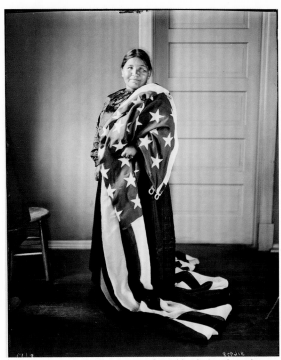

Photograph from the Wanamaker Expedition, 1913

AMERICAN INDIAN WEARING FLAG

Photograph from the Wells Expedition, 2003

INDIAN AMERICAN WEARING FLAG AS A SARI

PLATE 6

Flags, from the series "An Indian from India—
Portfolio II," 2001
Archival pigment print
12 x 16 inches
Courtesy of the artist and sepia EYE, New York

WHITEMAN AND INDIAN

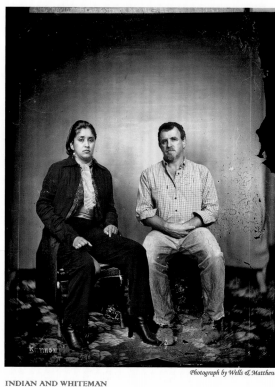

INDIAN AND WHITEMAN

PLATE 7

Indian with white man, from the series "An Indian from India—Portfolio II," 2001
Archival pigment print
12 x 16 inches
Courtesy of the artist and sepia EYE, New York

PLATE 8

Syrian Christian, from the series "An Indian from India—Portfolio II," 2001
Archival pigment print
12 x 16 inches
Courtesy of the artist and sepia EYE, New York

PLATE 9

Trans Cultural Indian, from the series "An Indian from India—Portfolio II," 2001
Archival pigment print
12 x 16 inches
Courtesy of the artist and sepia EYE, New York

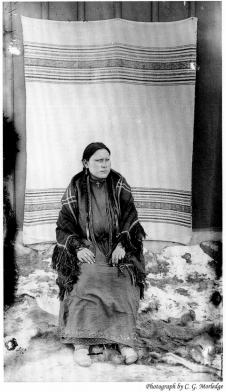

Photograph by C. G. Morledge

AN INDIAN CHRISTIAN

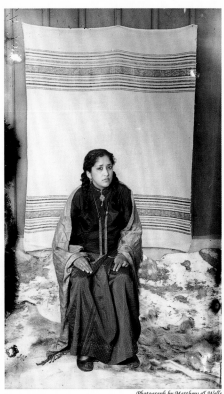

Photograph by Matthew & Wells

AN INDIAN MARTHOMA SYRIAN CHRISTIAN

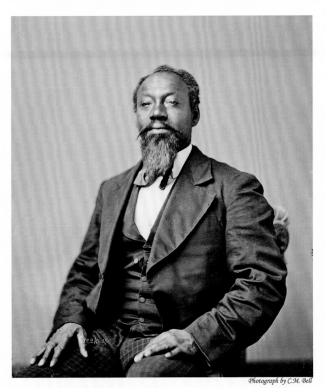

Photograph by C.M. Bell

HO-TUL-KO-MI-KO AKA SILAS JEFFERSON,
AFRICAN AMERICAN & INDIAN

Photograph by Matthew & Wells

ANNU PALAKUNNATHU MATTHEW AKA ANNA MATTHEW,
ENGLISH, AMERICAN & INDIAN

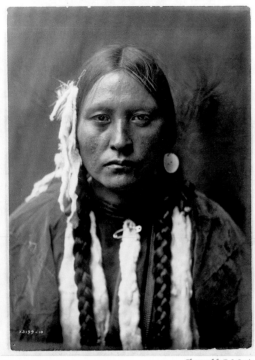

Photograph by E. S. Curtis

KUTENAI FEMALE TYPE

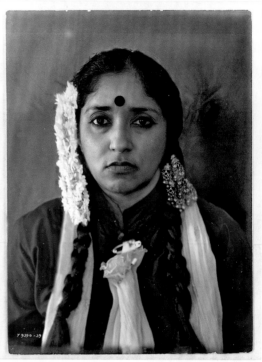

Photograph by Wells, Wells & Matthew

MALAYALEE FEMALE TYPE

PLATE 10

Types, from the series "An Indian from India—
Portfolio II," 2001
Archival pigment print
12 x 16 inches
Courtesy of the artist and sepia EYE, New York

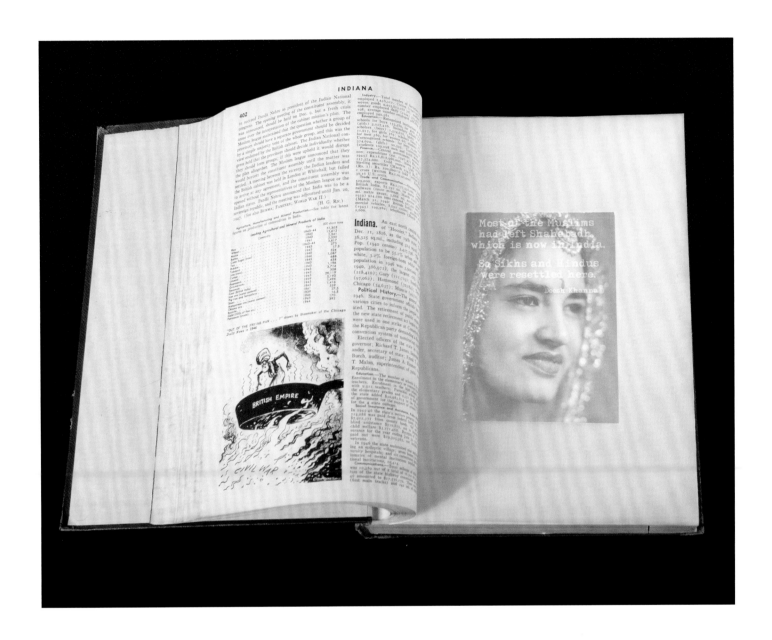

PLATE 11

Still from *Open Wound "1947"—Encyclopedia*,
2014

Photo animations and book

Animations 6 minutes, 51 seconds loop

Book 11 x 8 ⅝ x 1 ¾ inches

Collection of the Ulrich Museum of Art, Wichita

State University, Kansas

MADHUBAN MITRA

(born Kolkata, 1973; lives and works in Kolkata)

MANAS BHATTACHARYA

(born Kolkata, 1977; lives and works in Kolkata)

When faced with any apparently "abandoned" situation, it quickly becomes clear that a lot remains. Even the walls of a shut-down factory teem with life forms, only some of which are visible to the eye. To recognize this is to encounter the fecundity of residue. —Raqs Media Collective[1]

In 2009, around three decades after the launch of the National 35, touted as India's first indigenously produced 35mm analogue camera, Madhuban Mitra and Manas Bhattacharya visited the National Instruments Ltd. factory in Jadavpur in Kolkata for an extensive photographic project that resulted in "Through a Lens Darkly." Their project comprises a number of series of still photographs and animations including *Persistent Circuits*, *Temp Mort*, *Autopsy of the Great Indian Camera* (plate 1), *Post Datum* (plate 2), and "The Archaeology of Absence" (plates 3–11).

National Instruments, India's first and only still camera factory, had its origins in 1830 as the Mathematical Instruments Office. It provided the Land Survey Department of the colonial British government with various tools to survey and map the immense and varied topographies of their Indian colony. Renamed and relocated in 1957, it became a part of the decade-old independent government of India until 2009, when it was given to Jadavpur University. National Instruments' original mandate was

to produce high precision optical, mechanical, and electronic instruments for the land survey, meteorological, and defense departments, but its real legacy was undoubtedly the National 35. The camera was popular with Indian photographers for a few years in the 1980s, before it sank into oblivion, paralleling the decline of National Instruments Ltd., which ceased production in the early 1990s.

"Through a Lens Darkly" tells a story of India's relationship with photography; from early moorings in its role in surveillance and mapping, the making of an indigenous technology to serve the country's burgeoning interest in and practice of photography; to this project itself in which digital technology is used to create an archive of images about photography's analogue history. Mitra and Bhattacharya described their images as "photographs [that] also bear witness to the digital ruminating on the death of the analogue." The series also reflects the evolving state policies in industry, in particular the growth and decline of public sector companies that became defunct in the 1990s with economic liberalization. Alongside grand narratives of economic and technological experiments of a country in colonial and postcolonial times, the series offers an intimate glimpse into the lives of individuals who worked in the factory. Though people are absent in all the images, the space is saturated with their presence— clothing left behind, scattered prints and pamphlets. "The

Archaeology of Absence" also includes photographs of the camera assembly, where the device was actually manufactured. Today, the artists noted, it is a "dusty repository of broken camera shells, spare parts and debris" (plate 7).

Autopsy of the Great Indian Camera turns the camera's gaze onto itself, albeit a digital gaze on its historical analogue counterpart (plate 1). A set of six images shows the touted "Great Indian Camera" as a dismembered body: a case with four empty shells, a dusty body without a lens surrounded by its innards, minute close-ups of wires, cogs, and a stray aperture ring.

Post Datum, a set of twelve photographs, is a record of records, of the voluminous files and paperwork that are a hallmark of Indian bureaucracy and government (plate 2). Images of metal pallet-racks saturated with files, cord-bound covers containing applications for family pensions and benefits of expired factory workers, folios marked with labels for the Voluntary Retirement Schemes (VRS) that many workers chose when the factory became defunct, and pads of application-for-leave forms are brought together with images of sheets of paper strewn on the floor, cardboard petrified into sculptural forms, and printouts with punch holes at the margins that mark the transition of these offices into computer technology in the 1990s.

Mitra and Bhattacharya worked collaboratively over six months to create this project—an archive of absence. That absence echoed in residues and traces that remained on every stained windowpane, every dusty desk, numerous clocks bearing witness to a time that ended. Raqs Media Collective's observation rings particularly true for this project of photographing presence in absence. For this project, the artists worked like archaeologists excavating an abandoned site, peeling away the "fecundity of residue," the layers of forgetfulness, to reveal the relationship between the past and the present. Disallowing any easy

reading of loss and lament into the project, they wrote that their objective was to

create a photographic reality which stands in for and replaces the physical reality—the National Instruments Ltd. Factory—which will certainly not remain the same as a place, if it does not disappear altogether. As a caveat, we do not subscribe to any nostalgia for that which is vanishing. If there is a felt need to keep records of the place, it is because of what these records tell us about our present and our future, rather than a desire to preserve or conserve our past in all its "pastness."[2]

—LG

1 Raqs Media Collective, Curatorial note accompanying "The Rest of Now" Manifesta 7, *The European Biennial of Contemporary Art*, 2008, p. 4 (http://www.raqsmediacollective.net/images/pdf/0cda929c-8256-458c-99de-6bfd512b9c1d.pdf).

2 http://darklythroughalens.wordpress.com/about-us/.

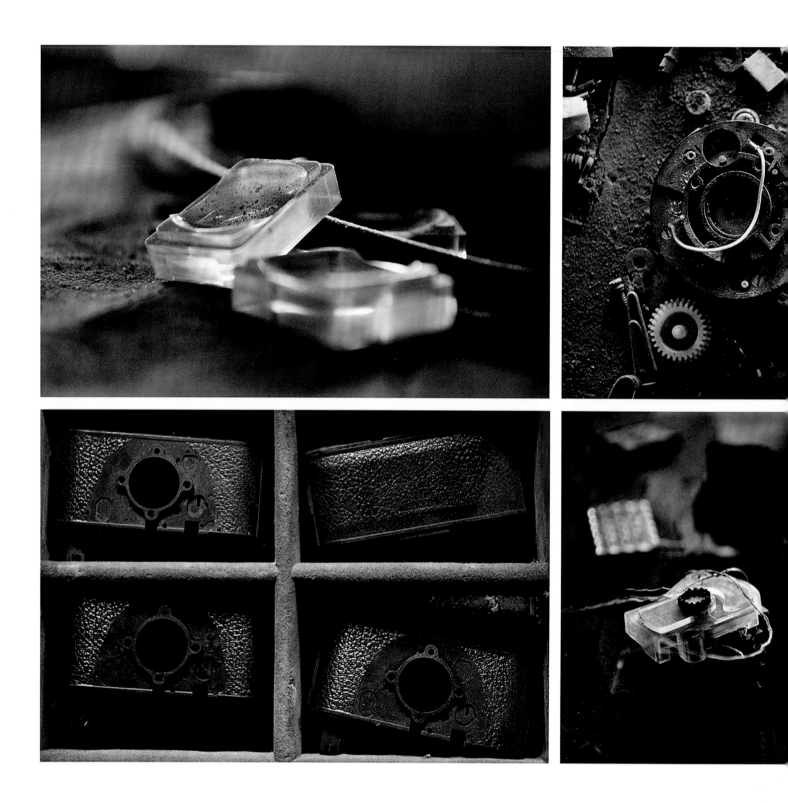

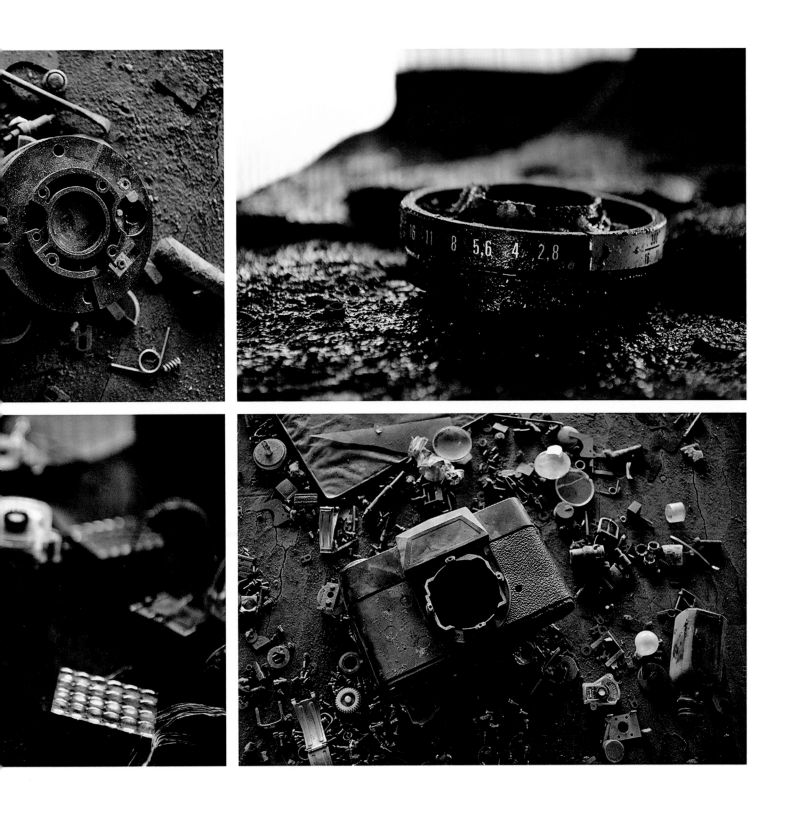

PLATE 1

Autopsy of the Great Indian Camera, 2009

Six pigment prints

10 x 15 inches each

Courtesy of the artists and Photoink, New Delhi

PLATE 2

Post Datum, 2009

Twelve pigment prints

10 x 15 inches each

Courtesy of the artists and Photoink, New Delhi

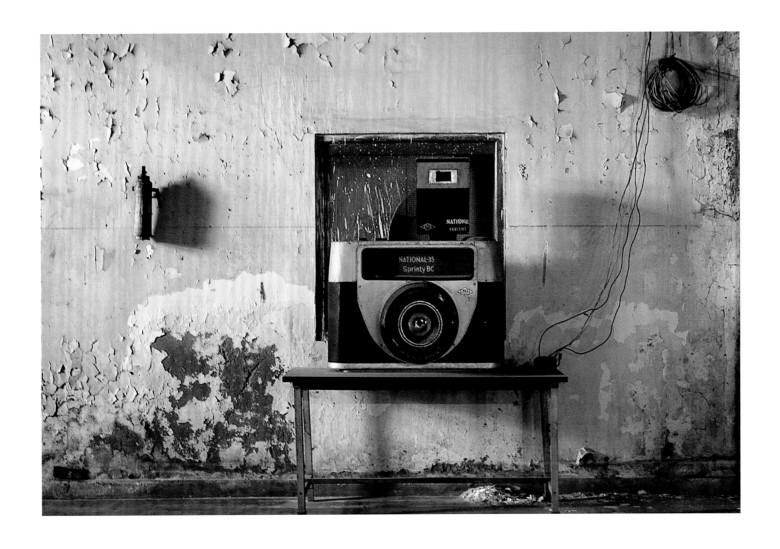

PLATE 3
Untitled, from the series "The Archaeology of
Absence," 2009
Pigment print
16 x 24 inches
Courtesy of the artists and Photoink, New Delhi

PLATE 4

Untitled, from the series "The Archaeology of
Absence," 2009
Pigment print
16 x 24 inches
Courtesy of the artists and Photoink, New Delhi

PLATE 5
Untitled, from the series "The Archaeology of
Absence," 2009
Pigment print
16 x 24 inches
Courtesy of the artists and Photoink, New Delhi

PLATE 6

Untitled, from the series "The Archaeology of
Absence," 2009
Pigment print
16 x 24 inches
Courtesy of the artists and Photoink, New Delhi

PLATE 7
Untitled, from the series "The Archaeology of
Absence," 2009
Pigment print
16 x 24 inches
Courtesy of the artists and Photoink, New Delhi

PLATE 8

Untitled, from the series "The Archaeology of
Absence," 2009
Pigment print
16 x 24 inches
Courtesy of the artists and Photoink, New Delhi

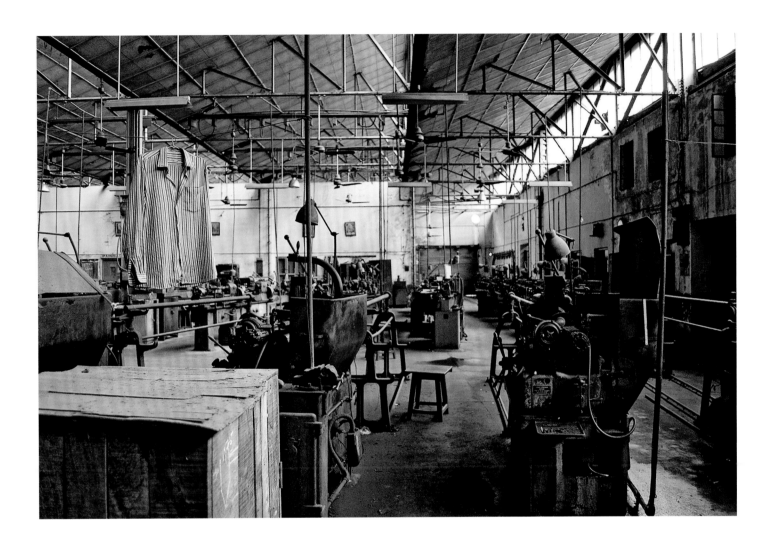

PLATE 9

Untitled, from the series "The Archaeology of
Absence," 2009
Pigment print
16 x 24 inches
Courtesy of the artists and Photoink, New Delhi

PLATE 10

Untitled, from the series "The Archaeology of
Absence," 2009

Pigment print

16 x 24 inches

Courtesy of the artists and Photoink, New Delhi

PLATE 11
Untitled, from the series "The Archaeology of
Absence," 2009
Pigment print
16 x 24 inches
Courtesy of the artists and Photoink, New Delhi

PUSHPAMALA N.

(born Bangalore, 1956; lives and works in Bangalore)

CLARE ARNI

(born Scotland, 1962; lives and works in Bangalore)

Pushpamala N.'s project "Native Women of South India: Manners and Customs" draws from the conceptual underpinnings of ethnographic colonial photography that sought to identify and inscribe racial and caste types based on outward markers such as facial features and skin color, clothing and ornamentation, and occupation, identified by the tools of the trade (plates 1–10). Expanding her field of referents to quote a range of images excavated from popular, historic, and ethnographic archives, Pushpamala created an album of women from South India as they have been imaged across centuries—in sixteenth-century miniature paintings, British ethnographic studies, prison photographs, early twentieth-century oil paintings, calendar icons, and popular religious prints circulated in the marketplace. She has written, "I am interested in the citational mode as a way of delving into a kind of collective memory, or modern folklore."[1]

Each photograph is the result of extensive collaborations. Pushpamala continued the cinematic methodology from her earlier series of photo-performances in the careful construction of the images, the attention to lighting, sets, costumes, and makeup, the posing of the body, and in directing the British photographer Clare Arni, with whom she worked on "Native Women of South India: Manners and Customs" and who also sometimes appears in the photographs. Pushpamala, herself a native of Bangalore, performed as the subject of most of the images. All the collaborators are credited in detail,[2] which underscores the physicality in the staging and making of every image that is "a combination of commercial products, visual technologies and professional expertise available in the local bazaar."[3] The complete project includes almost 250 photographs mounted in cheap frames and exhibited in the manner of a theater museum along with the painted backdrops, costumes, and props. Parul Dave Mukherjee wrote that Pushpamala's work "marks an inaugural moment in contemporary Indian art . . . [where] the performative body of the artist is photographed as an image and not as a photographic record of her performance."[4] Pushpamala has written of her interest in Andrei Tarkovsky's idea of film as "sculpture in time." Her own detailed sets are based on vernacular studio photography, into which she inserts her own body as a "living sculpture."[5]

"Native Women of South India: Manners and Customs" critiques the colonial ethnographic project and its effects, but simultaneously questions the popular representation of women within the national imagination. The surface of the images, like the surface of the body, provides visual clues that identify the icon being represented. Thus, the surface of the image is reproduced with exacting, in fact, excessive, fidelity. One easily recognizable image is that of a woman seated on rocks, holding the end of her sari to her bosom, wearing anklets and a toe

ring on her bare feet, and illuminated by a saffron-tinged moon (plate 7). She looks out at the nineteenth-century "gentleman artist"/viewer Raja Ravi Varma, who modeled himself on the itinerant European artists in India at that time seeking commissions from both British and local patrons. Ravi Varma became one of the most well-known and popular Indian artists who worked in the "Western academic style" using oil paints. In order to be contemporary, Ravi Varma took on the Western academic style and painted scenes from epic Indian mythology as an inspiring nationalist enterprise. Languid women, in particular, represented the ideal heroines, albeit garbed and imaged in contemporary fashion (see page 17, figure 1). Ashish Rajadhyaksha has written about how Pushpamala's work questions the notions of "original" and "authenticity"—with the copy being more detailed than its referent.[6] Moreover, Pushpamala raises invisible subtexts such as the relationship between the artist and his model and also that the "original" model may have been from the western Indian state of Gujarat and not the ideal South Indian beauty that she represents. Geeta Kapur pointed out that it is in the "surfeit of representation, in what otherwise appears to be an exercise in plain mimesis. . . . It is through an indulgent iconophilia that she [Pushpamala] acquires the sanction for a conceptually iconoclastic—and political—form of alterity."[7]

In another photo-performance from the series, Pushpamala re-created a colonial anthropometric image of a Toda tribal woman (plate 5 and cover). She darkened her skin, donned the traditional white drape, and posed with one arm outstretched against the backdrop of a measuring graph. To finish the mock simulation of a historical moment—complete with its contemporaneous technology—she produced the image in black and white. However, this re-creation contains an intentional slippage: her colonial counterpart was bare-chested (see page 18, figure 3), but Pushpamala covered her body with the cloth, a gesture that inserts her subjectivity into the image.

Pushpamala could be described as a *baharupiya*—one who disguises herself and assumes multiple identities—with each guise focusing the lens sharply on the subject, intent, and method of representation. The art-historical enactment serves to deconstruct the "original" and through the subjective double-representation, Pushpamala takes charge of the narrative and its potential reception. "Native Women of South India: Manners and Customs" raises complex questions about historical and contemporary representations of female bodies as well as the relationship between masquerade and identity, between the performative self and the represented other; it also critiques art-historical categories of high and low art. —LG

1 Pushpamala N., Interview with Parul Dave Mukherjee, in Gayatri Sinha, ed., *Voices of Change: 20 Indian Artists* (Mumbai: Marg, 2010).

2 Ajay Sinha, "Pushpamala N. and the 'Art' of Cinephilia in India," in Christiane Brosius and Roland Wenzlhuemer, eds., *Transcultural Turbulences: Towards a Multi-Sited Reading of Image Flows* (Heidelberg, Transcultural Research—Heidelberg Studies on Asia and Europe in a Global Context: Springer, 2011).

3 Ibid.

4 Parul Dave Mukherjee, "Pushpamala N: Self in Stills, Conflict within the Frame," in Gayatri Sinha, *Voices of Change: 20 Indian Artists*, 62.

5 Pushpamala N., 72.

6 Ashish Rajadhyaksha, "The Elimination of Authenticity," in *Native Women of South India: Manners and Customs* (Delhi: Nature Morte, 2007).

7 Geeta Kapur, "Gender Mobility: Through the Lens of Five Women Artists," in Gayatri Sinha, ed., *Art and Visual Culture in India 1857–2007* (Mumbai: Marg, 2009).

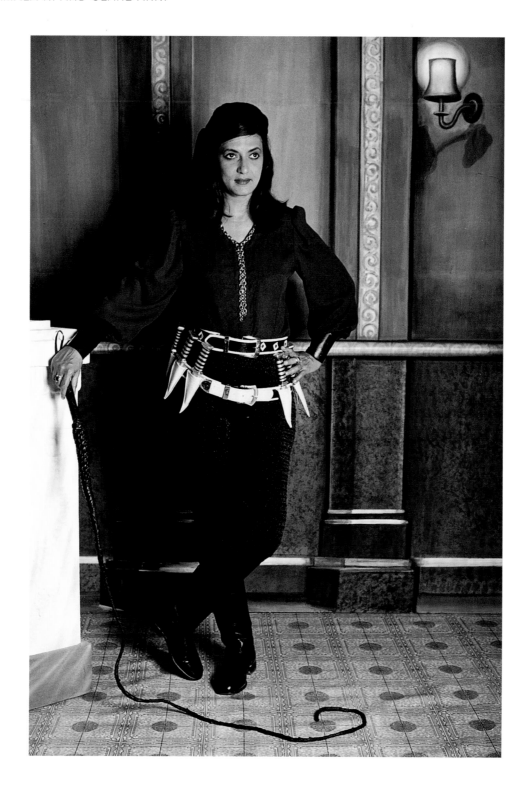

PLATE 1

*The Native Types—Cracking the Whip (after a
1970s Tamil film still of Jayalalitha)*, from the
project "Native Women of South India: Manners
and Customs," 2000–2004
Chromogenic print on metallic paper
22 x 14 ¾ inches
Collection of Dipti and Rakesh Mathur
Courtesy of the artist and Nature Morte, New Delhi

PLATE 2

The Native Types—Returning from the Tank (after a painting by Raja Ravi Varma), from the project "Native Women of South India: Manners and Customs", 2000–2004

Chromogenic print on metallic paper

22 x 13 ½ inches

Collection of Dipti and Rakesh Mathur

Courtesy of the artist and Nature Morte, New Delhi

PLATE 3

The Native Types—Lakshmi (after an early twentieth-century oleograph from Ravi Varma Press), from the project "Native Women of South India: Manners and Customs," 2000–2004
Chromogenic print on metallic paper
22 x 14 ¾ inches
Collection of Dipti and Rakesh Mathur
Courtesy of the artist and Nature Morte, New Delhi

PLATE 4

The Native Types—Flirting (after a 1990s Kannada film still), from the project "Native Women of South India: Manners and Customs," 2000–2004
Chromogenic print on metallic paper
22 x 16 ½ inches
Collection of Dipti and Rakesh Mathur
Courtesy of the artist and Nature Morte, New Delhi

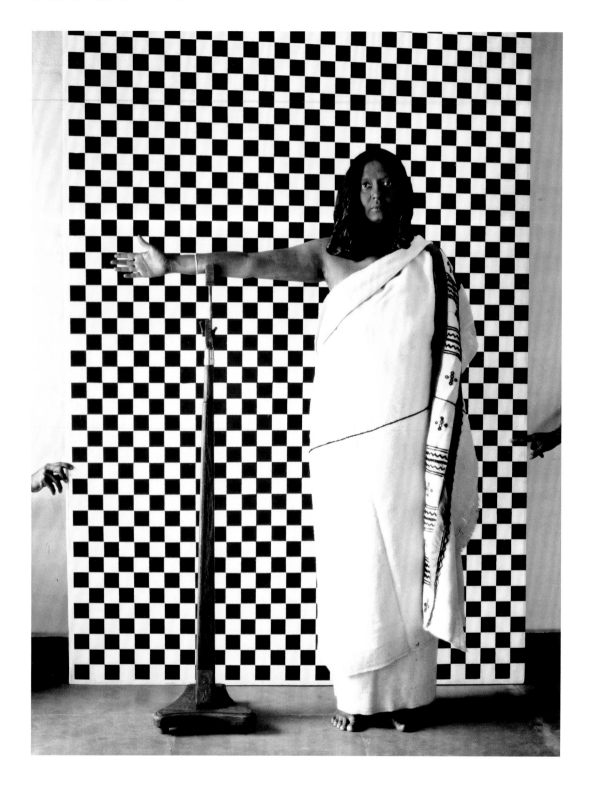

PLATE 5

*The Native Types—Toda (after a late nineteenth-
century British anthropometric photograph),*
from the project "Native Women of South India:
Manners and Customs," 2000–2004
Sepia-toned gelatin silver print
22 x 16 ½ inches
Collection of Dipti and Rakesh Mathur
Courtesy of the artist and Nature Morte, New Delhi

PLATE 6

The Native Types—Criminals (after a 2001 police photograph), from the project "Native Women of South India: Manners and Customs," 2000–2004
Gelatin silver print
15 x 22 inches
Collection of Dipti and Rakesh Mathur
Courtesy of the artist and Nature Morte, New Delhi

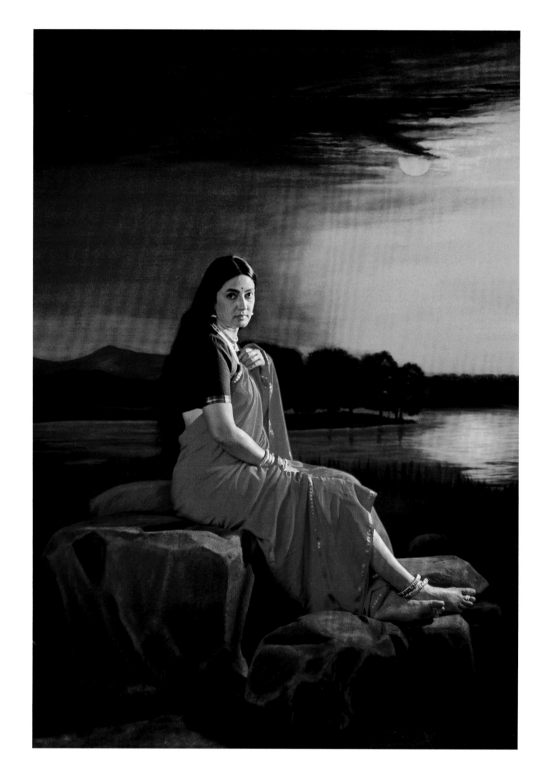

PLATE 7

*The Native Types—Lady in Moonlight (after an
1889 Raja Ravi Varma painting)*, from the project
"Native Women of South India: Manners and
Customs," 2000–2004
Chromogenic print on metallic paper
22 x 15 inches
Collection of Dipti and Rakesh Mathur
Courtesy of the artist and Nature Morte, New Delhi

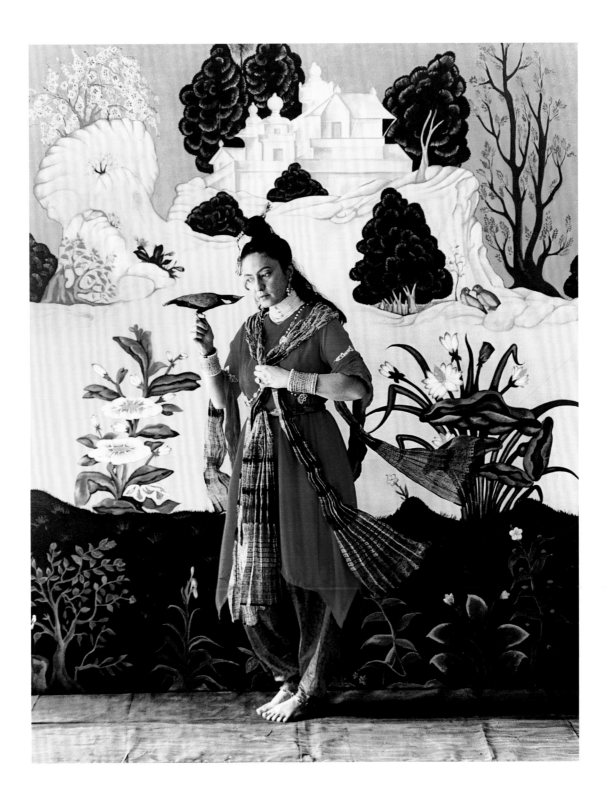

PLATE 8

The Native Types—Yogini (after a sixteenth-century
Deccani painting), from the project "Native Women of
South India: Manners and Customs," 2000–2004
Chromogenic print on metallic paper
22 x 17 ½ inches
Collection of Dipti and Rakesh Mathur
Courtesy of the artist and Nature Morte, New Delhi

PLATE 9

*The Native Types—Circus (after the photograph
Famous Circus by Mary Ellen Mark),* from the
project "Native Women of South India: Manners
and Customs," 2000–2004
Chromogenic print on metallic paper
15 x 22 inches
Collection of Dipti and Rakesh Mathur
Courtesy of the artist and Nature Morte, New Delhi

PLATE 10

The Native Types—Our Lady of Velankanni (after a contemporary votive image), from the project "Native Women of South India: Manners and Customs,"
2000–2004
Chromogenic print on metallic paper
22 x 14 ¾ inches
Collection of Dipti and Rakesh Mathur
Courtesy of the artist and Nature Morte, New Delhi

RAQS MEDIA COLLECTIVE

(Jeebesh Bagchi, born New Delhi, 1965; Monica Narula, born New Delhi, 1969; Shuddhabrata Sengupta, born New Delhi 1968; live and work in New Delhi)

Raqs Media Collective was founded in 1992 by Jeebesh Bagchi, Monica Narula, and Shuddhabrata Sengupta, who trained as filmmakers at the Jamia Millia Islamia University in Delhi. The name "Raqs" (pronounced "rux") is derived from "a word in Persian, Arabic, and Urdu and means the state that whirling dervishes enter into when they spin. It is also a word used for dance. At the same time, Raqs could be an acronym for 'rarely asked questions.'"[1]

Raqs's practice assumes multiple forms and follows several intersecting trajectories. It is deeply rooted in the historical, yet is constantly vigilant of the processes through which history is constructed (plates 1–5). One way to understand history is the unfolding of events in particular places at specific moments in time. Place and time have long been essential conceptual and philosophical concerns in Raqs's work. Explorations into the malleability and simultaneity of time have informed a range of installations, objects, curated projects, and texts. Raqs's understanding of place releases it from the solidity of territories:

We think that the concept of place can never be abandoned. It's just that how we recognize place, and being placed, is constantly in flux. The "where" of everywhere is a function, it varies depending on what it is being made to do, how it is being looked at, what it is seen in relation to. Place is an entity that derives in equal measure from entangled networks of productive journeys on the ground and imaginaries in the air. The fact that Capitalism shapes our sense of place, our understanding of limits and boundaries today in a certain very specific way does not mean that these will be understood very differently tomorrow. We look forward to the overhauling of all our co-ordinates of place, time and placeless-ness which will accompany the challenges that Capitalism will have to face everywhere. Places will be thought more with a will to horizons than with a grief of territories.[2]

In 2000, Raqs founded Sarai at the Centre for the Study of Developing Societies in Delhi. "Sarai" means a meeting place; sarais were built as way stations for travelers along trade routes. With the influx of multiple cultures, great urban centers grew up around them. Sarai is a laboratory for research and experiments: "a physical as well as a conceptual space. And it is committed to transcending the false categorical distinction that privileges either local or global vantage points. The point is to think the world in every place, and to be committed to what is unique and distinctive in every part of the world. This means a certain ambidexterity when it comes to spatial commitments, a willingness to be both anchored as well as airborne."[3] Sarai supported residential workshops for cultural practitioners, research projects on intellectual property, on the politics of information availability, language, the notions

of the contemporary, and urban studies. *The Sarai Reader* journal published eight issues devoted to critical, conceptual, and creative explorations into themes such as "The Public Domain," "The Cities of Everyday Life," "Shaping Technologies," "Crisis/Media," "Turbulence," "Frontiers," and "Fear." The culminating ninth issue, *Sarai 09*, took the form of a published book and an arts laboratory, curated by Raqs, on the premises of the Devi Art Foundation, a private contemporary art museum in Gurgaon, on the outskirts of Delhi. From August 2012 to April 2014, the space served as both a studio and a gallery for more than 110 proposals across diverse fields.

Earlier significant curatorial projects by Raqs include *Building Sight* (2006) at the Württembergischer Kunstverein Stuttgart, an exploration of urban systems and space in rapidly developing Asian cities; *The Rest of Now* for Manifesta 7 (2008), sited in a disused aluminium factory in Bolzano, Italy; and *Insert 2014—The Sharp Edge of the Global Contemporary* (2014) in Delhi. The last project included an exhibition with more than twenty artists, proposals to critically re-image public sites and the cultural infrastructure of the city, and performances and talks by international practitioners.

Raqs has also collaborated on performative works, most notably with theater practitioner Zuleikha Chaudhari. *Seen at Secunderabagh* (2011), with Chaudhari and Manish Chaudhari, took as its starting point an 1858 photograph by Felice Beato shot at Lucknow, the site of a bloody suppression by the British of a mutiny against colonial rule (see pages 156–59, figures 1–3). The work delved into the role of images in constructing history, the "deception of images,"[4] the demarcation between fact and fiction, and questioned the separation of time into registers of past, present, and future. In the seminal text of *In the Theater of Memory: The Work of Contemporary Art in the Photographic Archive*, Raqs wrote about photography as theater (see page 155).

Raqs's own description of their practice is perhaps the best. They embrace variety and

enjoy playing a plurality of roles, often appearing as artists, occasionally as curators, sometimes as philosophical agent provocateurs. They make contemporary art, have made films, curated exhibitions, edited books, staged events, collaborated with architects, computer programmers, writers and theatre directors and have founded processes that have left deep impacts on contemporary culture in India. Raqs follows its self declared imperative of "kinetic contemplation" to produce a trajectory that is restless in terms of the forms and methods that it deploys even as it achieves a consistency of speculative procedures.[5]

—LG

1 Francesco Manacorda, "Raqs Media Collective: Focus," *Frieze* 108 (June–August 2007), http://www.frieze.com/issue/article/raqs_media_collective/.

2 Silvia Calvarese, "'We are never out of place, wherever we may be' Interview with Raqs Media Collective," *Roots Routes—Research on Visual Culture* 1, 4 (October–December 2011), http://www.roots-routes.org/2011/11/14/space-is-a-doubtraqsdi-silvia-calvarese/.

3 Ibid.

4 http://www.raqsmediacollective.net/works.aspx#.

5 http://www.raqsmediacollective.net/.

PLATE 1

Ceasural Variation I, 2007

Paired films

Dimensions variable

Run time 3 minutes, 18 seconds

Courtesy of the artists

PLATE 2

Ceasural Variation II, 2007

Paired films

Dimensions variable

Run time 3 minutes, 53 seconds

Courtesy of the artists

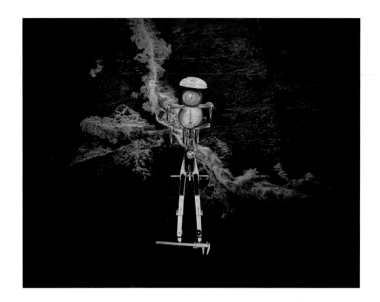

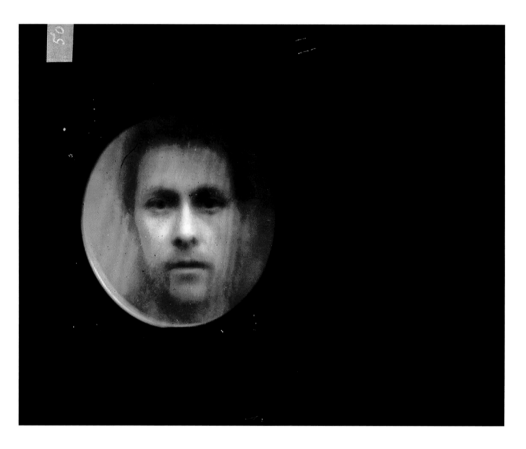

PLATE 3

Still from *The Surface of Each Day is a Different Planet*, 2009
Installation with furniture, illumination, and projected single-screen video
Dimensions variable
Run time 38 minutes
Courtesy of the artists

PLATE 4

Still from *The Surface of Each Day is a Different Planet*, 2009
Installation with furniture, illumination, and projected single-screen video
Dimensions variable
Run time 38 minutes
Courtesy of the artists

PLATE 5

The Surface of Each Day is a Different Planet,
2009
Installation with furniture, illumination, and
projected single-screen video
Dimensions variable
Run time 38 minutes
Courtesy of the artists

VIVAN SUNDARAM

(born Simla, 1943; lives and works in New Delhi)

Since the 1970s, Vivan Sundaram's prolific work as an artist and activist have seen many overlaps. In 2001, Sundaram created a series of thirty-eight photo-montages that digitally juxtapose individuals from three generations of his family in a complex orchestration and recasting of relationships (plates 1–12). In "Re-Take of Amrita," Sundaram carefully culled from his family archive, collapsing time and space by bringing together people and places across decades, from locations in India and Europe, to create fictional scenarios. He arranged the characters in imagined and semibiographical narratives based upon his subjective, retrospective reading of the internal dynamics among different individuals. Sundaram drew upon photographs, paintings, and also personal letters from his maternal aunt, Amrita Sher-Gil (1913–1941), arguably the best-known woman painter in pre-independent India and a voracious writer.

Sundaram was born to Indira (1914–1975), the younger daughter of Umrao Singh Sher-Gil (1870–1954), the son of a Punjab chieftain, and Marie Antoinette (1882–1948), a Hungarian woman who was Umrao Singh Sher-Gil's second wife. Their older daughter, Amrita Sher-Gil, lived and worked in India and Europe; her paintings reflect the two worlds she inhabited and encountered in her self-proclaimed quest to understand her roots. Her father, Sundaram's grandfather, was a keen amateur photographer, who in the early years of photography in India relentlessly photographed his family and himself. His rich archive of images ranges from the early 1890s to 1947.

Sundaram reads an undertone of "radiating desire" and "seduction" in the photographs of Umrao Singh, Marie Antoinette, and their daughters, which he then re-created visually by digitally juxtaposing photographs and paintings from the family archive. For example, in *Presenting Papa*, a regal Umrao Singh wears only a loin cloth, his long hair loose over his shoulders (plate 6). An adult Amrita, photographed in Paris, stands before him, touching her father on his shoulder. In *Preening,* a much younger Umrao Singh, taken from a 1904 self-portrait, stands in a similar pose before his wife, whose languid, slouching body Sundaram described as conveying "conjugal love" (plate 5). Both photo-montages are presented in indoor settings elaborately arranged in the manner of studio backdrops with furniture, drapes, and bourgeois bric-a-brac. The almost nude Umrao Singh is brought into sharp contrast with the clothed European woman—signaling the dual cultural influences on the family.

One of the most complex images from the series is *Bourgeois Family: Mirror Frieze* (plate 1). The women in Sundaram's family are the central protagonists; they look into mirrors, their backs to the viewer. Also watching their reflections are Umrao Singh and Sundaram himself, who appears as a small boy seated on his grandfather's lap and holding a camera—a witness to a history that he has

devised. Here, Sundaram used mirrors, a frequent motif in Umrao Singh's photographs, as an effective pictorial device to signal the multiple temporal planes and the transitions his family makes through them—which they appear to witness by looking upon themselves. He described his method as well as the psychological intent in making this montage:

Several self absorbed young women are looking into mirrors. In the centre is Marie Antoinette, a European woman, wearing a gorgeous oriental robe. She is pregnant with the baby that will be named Amrita. To her right is the now grown-up daughter Amrita—but there are two Amritas, one Indian and the other Hungarian, reflected in the mirror. Digital cloning plays on aspects of identity and masquerade; here, Amrita's attire is an index to her mixed parentage. In the same photo-frieze, a mirror frames . . . my mother Indira. I too am seen reflected in a mirror, seated in my grandfather's lap. He is inducting me into this "collaborative" photographic project. Umrao Singh is the "essential" photographer; I will orchestrate the images with a digital wand half a century later. In excavating the photograph of the artist as a boy with a Voigtlander camera, I signal a provocative relationship. An artist using his family archive of photographs to make "future" works of art: what kind of "genetic" manoeuvre, what kind of narcissistic relay, does this unwind?[1]

Indira, Sundaram's mother, whom he described as the "self-effacing" second daughter, was the subject of her father's photographs and her sister's paintings. In *Sisters with* Two Girls (plate 10), Sundaram brought together Amrita and Indira against the backdrop of one of Amrita's most enigmatic paintings, *Two Girls* (Collection of Vivan Sundaram, New Delhi), painted in 1939. A slender, fair-skinned girl stands assured and confident in a frontal posture, her weight resting on her left leg. Her left arm is placed around the shoulders of a seated figure whose dark skin clearly marks her racial difference. In this painting,

the nudes take on a performative role, embodying Sher-Gil's quest to negotiate her Indian and European identities. *Two Girls* has also been described as being emblematic of Amrita Sher-Gil's bisexuality. Sher-Gil created a complex web of relationships, which Sundaram doubled in the placement of the sari-clad figures of the two sisters. Indira sits behind the languorously reclining Amrita, who—unlike the other three female figures in the frame—looks at the photographer-viewer.

Indira's painted and photographed images are juxtaposed again in *Style* (plate 11). A confident Indira, photographed by her father in Simla in 1937, stands behind a seated Indira wearing the same gold-edged sari, painted by Amrita a year earlier. The photo-montage shows Indira as she was seen and imaged by three gazes, those of her father, her sister, and her son.

Although "Re-Take of Amrita" is an intensely personal and subjective excavation of a family archive, the family itself was in the public eye and at the forefront of the making of modern Indian art. In many ways, the Sher-Gil family represented the transition of the country itself, from its colonial past into nationhood.
—LG

1 Vivan Sundaram, "Preface," in *Re-take of Amrita* (Delhi: Tulika Books, 2001).

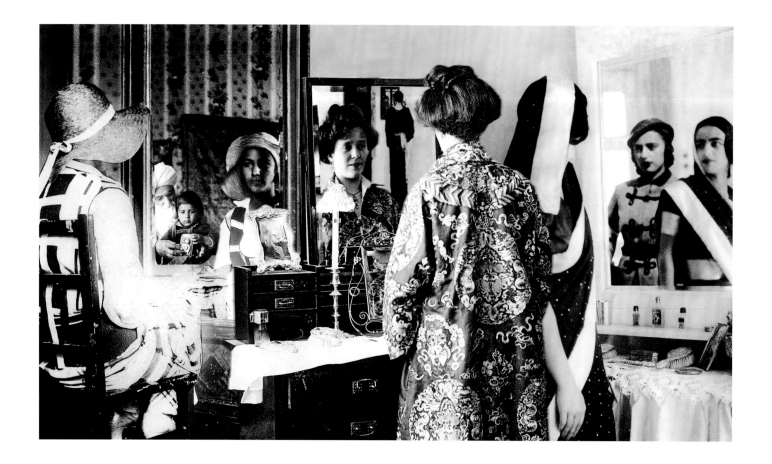

PLATE 1

Bourgeois Family: Mirror Frieze (Indira, Paris,
1930; Umrao Singh and Vivan, Simla, 1946; Marie
Antoinette, Lahore, 1912; Small Earring, 1893,
by Georg Hendrik Breitner; Amrita, Simla, 1937;
Amrita, Budapest, 1938, photo, Victor Egan),
from the series "Re-Take of Amrita," 2001–2002
Archival digital pigment print
15 x 26 inches
Courtesy of the artist and sepia EYE, New York

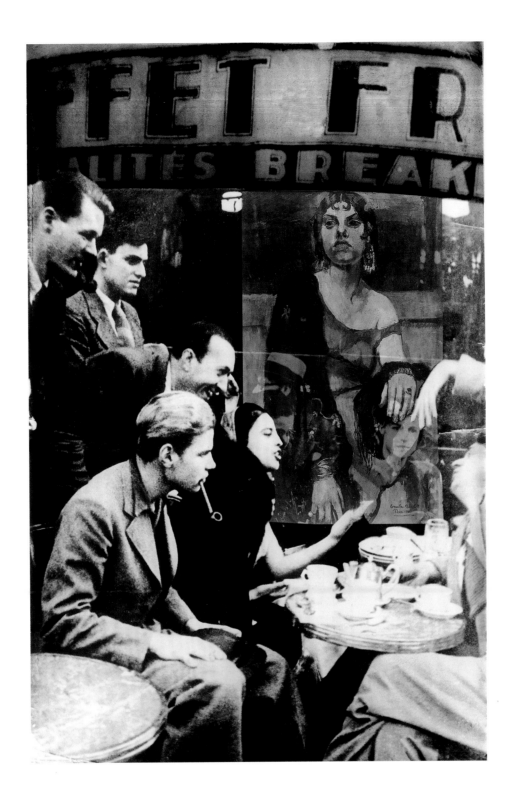

PLATE 2

Café-talk (Amrita with art school colleagues,
Paris, 1932, photo, unknown; Spanish Girl,
detail, 1933, by Amrita Sher-Gil), from the series
"Re-Take of Amrita," 2001–2002
Archival digital pigment print
19 x 12 ½ inches
Courtesy of the artist and sepia EYE, New York

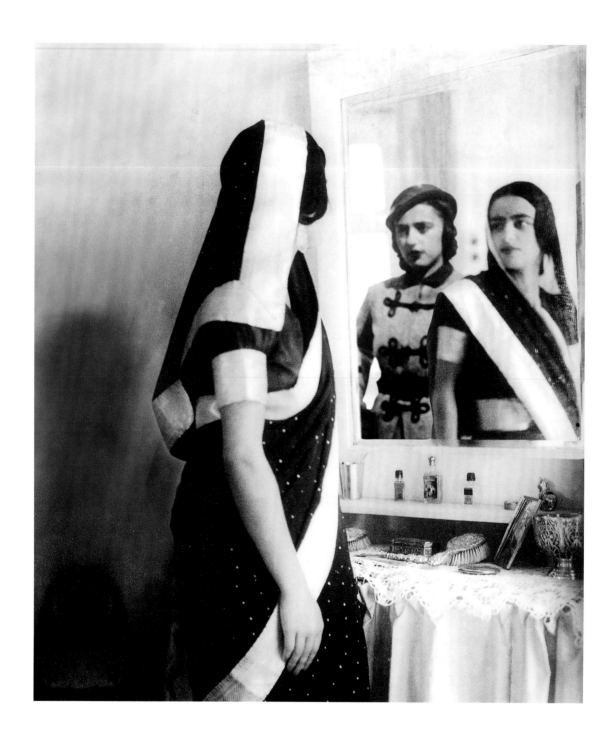

PLATE 3

Doppelgänger (Amrita, Simla, 1937; Amrita, Budapest, 1938, photo, Victor Egan), from the series "Re-Take of Amrita," 2001–2002

Archival digital pigment print

15 x 13 inches

Courtesy of the artist and sepia EYE, New York

123

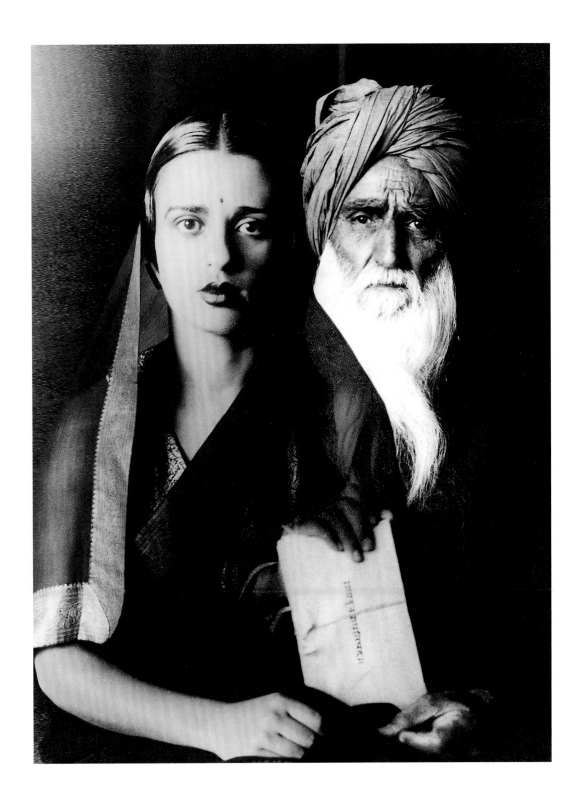

PLATE 4

Father-Daughter (Umrao Singh, Simla, mid-1940s; Amrita, Simla, 1937), from the series "Re-Take of Amrita," 2001–2002

Archival digital pigment print

19 x 14 inches

Courtesy of the artist and sepia EYE, New York

PLATE 5

Preening (Marie Antoinette, Lahore, 1912;
Umrao Singh, 1904), from the series "Re-Take of
Amrita," 2001–2002
Archival digital pigment print
15 x 21 inches
Courtesy of the artist and sepia EYE, New York

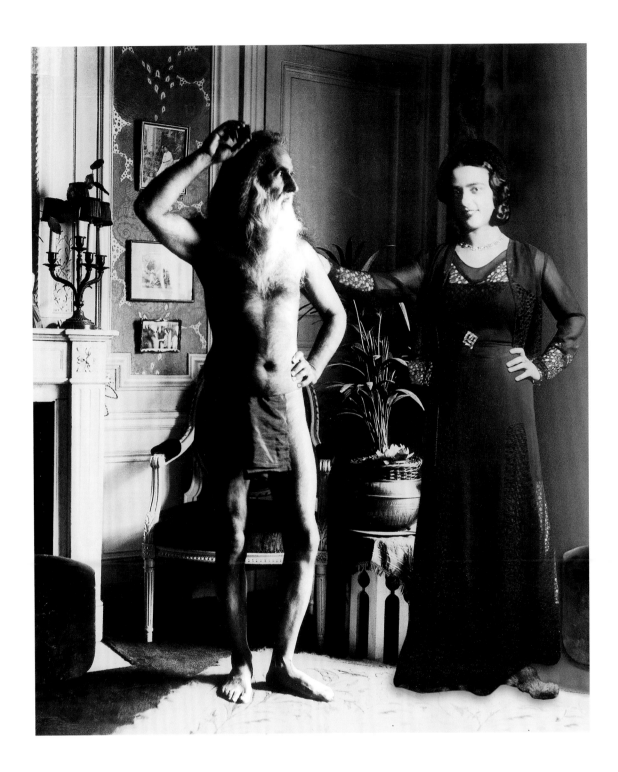

PLATE 6

Presenting Papa (Umrao Singh, Paris, 1930;
Amrita, Paris, early 1930s), from the series
"Re-Take of Amrita," 2001–2002
Archival digital pigment print
15 x 12 ½ inches
Courtesy of the artist and sepia EYE, New York

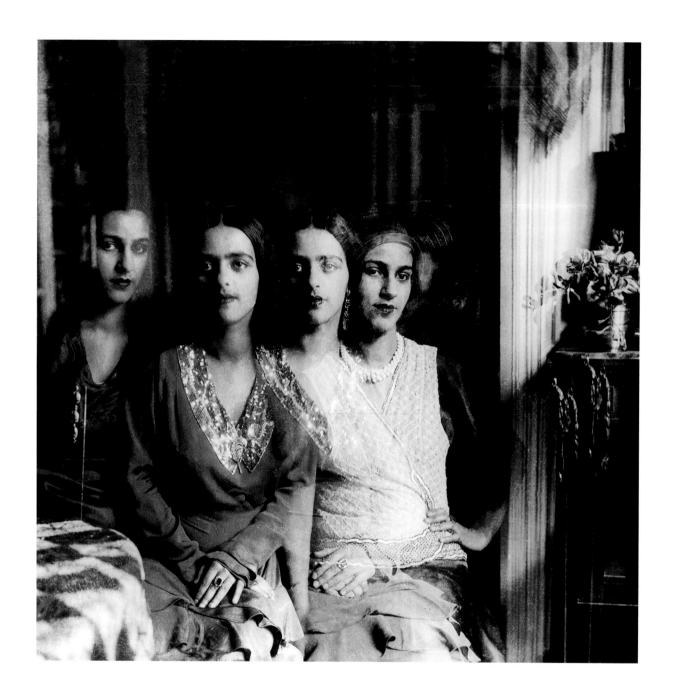

PLATE 7

Quartet (double-exposure by Umrao Singh;
portraits of Amrita and Indira, Paris, 1931), from
the series "Re-Take of Amrita," 2001–2002
Archival digital pigment print
15 x 15 inches
Courtesy of the artist and sepia EYE, New York

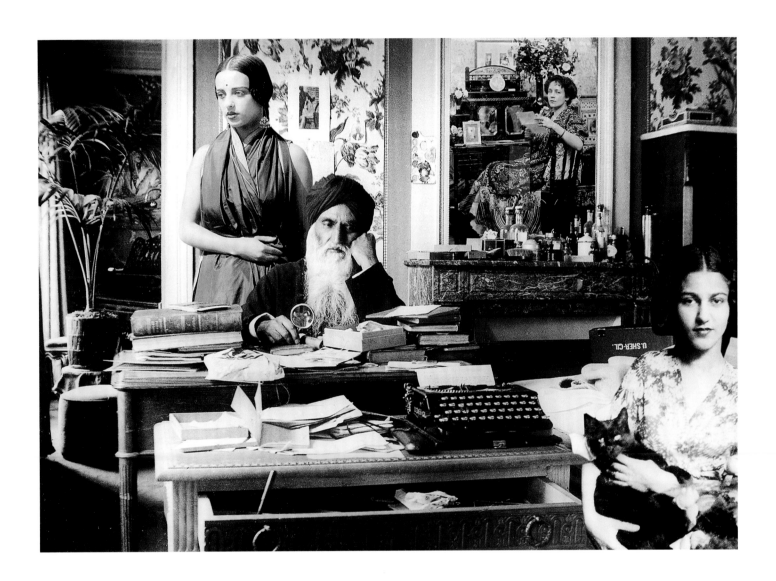

PLATE 8

Remembering the Past, Looking to the Future
(Umrao Singh, Paris, early 1930s; Amrita,
Bombay, 1936, photo, Karl Khandalavala; Marie
Antoinette, Lahore, 1912; Indira, Paris, 1931),
from the series "Re-Take of Amrita," 2001–2002
Archival digital pigment print
15 x 21 inches
Courtesy of the artist and sepia EYE, New York

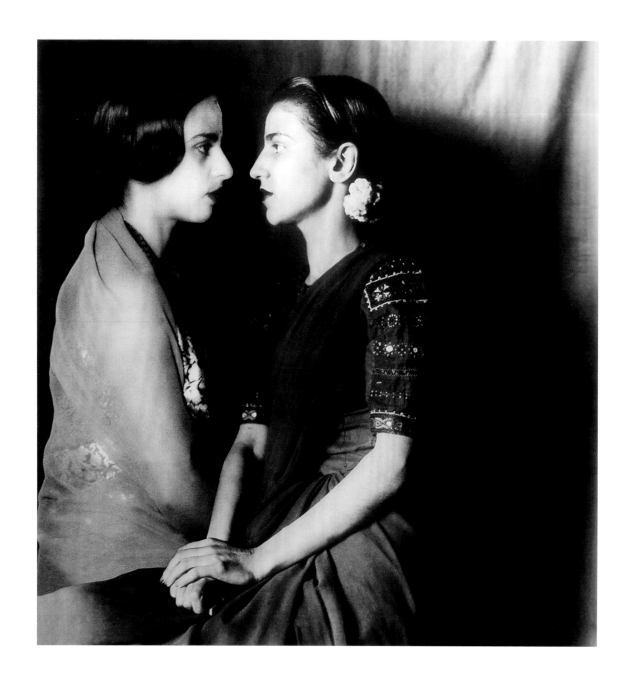

PLATE 9

Sisters Apart (Amrita, Simla, 1937; Indira, Simla, early 1940s), from the series "Re-Take of Amrita," 2001–2002
Archival digital pigment print
15 x 14 ¼ inches
Courtesy of the artist and sepia EYE, New York

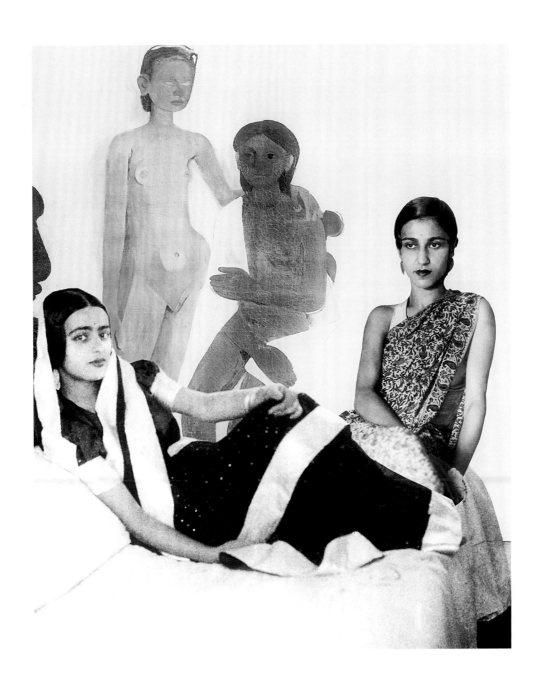

PLATE 10

Sisters with Two Girls (Amrita, Simla, 1937;
Indira, Simla, early 1940s; Two Girls, *detail, 1939,*
by Amrita Sher-Gil), from the series "Re-Take of
Amrita," 2001–2002
Archival digital pigment print
15 x 12 ¼ inches
Courtesy of the artist and sepia EYE, New York

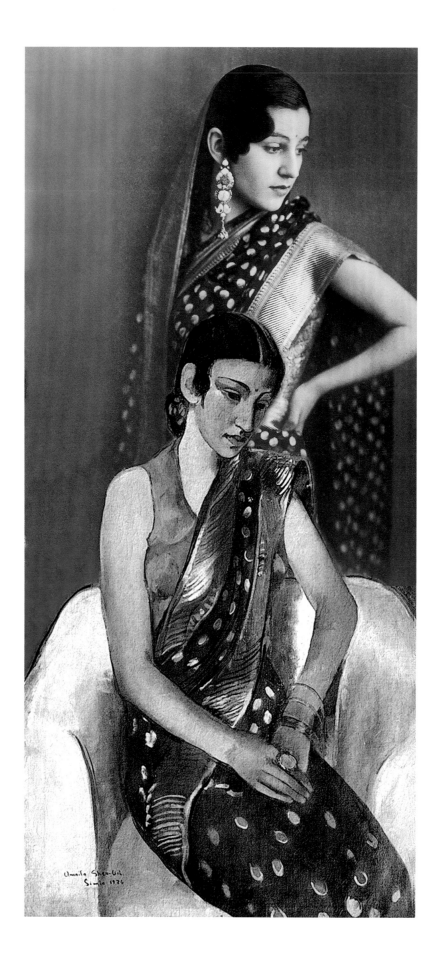

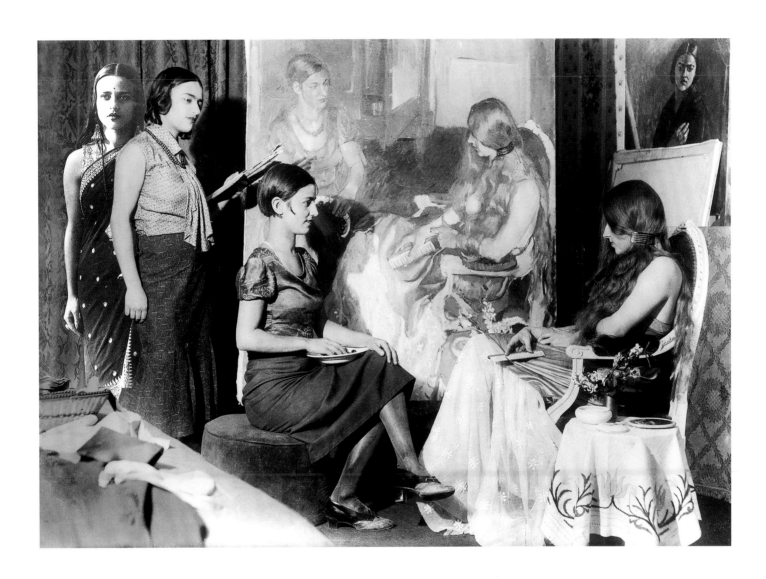

PLATE 11

Style (Indira, Simla, 1937; Portrait of Sister, 1936, by Amrita Sher-Gil), from the series "Re-Take of Amrita," 2001–2002

Archival digital pigment print

22 x 10⅛ inches

Courtesy of the artist and sepia EYE, New York

PLATE 12

Young Girls *Recomposed (Indira and Denise in front of* Young Girls, *1932, by Amrita Sher-Gil; Amrita, Simla, 1937),* from the series "Re-Take of Amrita," 2001–2002

Archival digital pigment print

15 x 21⁵⁄₁₆ inches

Courtesy of the artist and sepia EYE, New York

SUREKHA

(born Bangalore, 1965; lives and works in Bangalore)

In work that spans a wide range of media, including video, photography, performance, and installation, Surekha has focused on the body, particularly the female body, and its location in public and private spaces. She melds thematic content with the process of making the work. She features her own body in many video and photo works that blur the boundaries between what constitutes fiction and fact in everyday activities.

In her ongoing exploration of this conceptual theme, in 2001 Surekha created *Fragments of a Wedding Diary*, an installation with thirty-three images culled out of found wedding photographs from studios across Bangalore (plates 1–4). The genesis of the project lay in Surekha's determination to find examples that symbolize the "common man's desire to get photographed." Her search led her to some of the oldest photo studios in the city, where she found that the majority of images were of South Indian weddings. She began to question the reality that is constructed in and through the act of making images, in which the subjects who are photographed are removed from "reality" to become actors, as it were, in the drama of a wedding photograph or video. The wedding videography and photography industry thrives across India with small studios specializing in particular aesthetics of framing and special effects. Surekha described the historic role of the wedding photographer in a South Indian city such as Bangalore:

The marriage photographs have a special cultural position in a metropolitan city like Bangalore. It is a historic belief that the art of photography traversed from quantitatively fewer (in the 1960s) black and white monochromes—through multicolored, quantitatively more (1990s)—to video films of every marriage ritual. A specific mode of framing and picturization of the occasion has been set within the working methodology of every marriage photographer. It is so because marriage photographers have their own definition of what they mean by the term "creativity" and are very particular in the usage of what they mean by special effects.[1]

Surekha extracted fragments from the photographs and negatives to focus on details (plates 3 and 4), obliterating in the process larger fixed narratives that the images may have conveyed. In her examination of the images, Surekha discovered that many moments in a wedding ceremony focus on the act of touching. Consequently, in *Fragments of a Wedding Diary*, she manipulated the images, many of which she hand-colored and drew upon, to communicate the ritual of touch, whether through hands folded or a garland of flowers coming in contact with a body.

A similar process of collecting found images to create an assemblage underlies *The Fragrance of Jasmine* (plate 5), an installation of eighty-three photographs Surekha made in 2002, during a workshop in Mysore.

Surekha collected these photographs from Raj Bros, a photo studio in Mysore that had been established by the grandfather of the owner she met in 2002. The studio had a rich archive of images, in which they had preserved almost all the photographs made in the studio over a period of six decades.[2]

The Fragrance of Jasmine continues Surekha's overarching conceptual focus on the female body and its representation. The title alludes to the braids of jasmine blossoms that women across South India wear in their hair—both on an everyday basis and on ceremonial occasions. Surekha described these images as expressive of "the saga of the traditional jasmine-flower braid that captures the cycle of womanhood from birth through puberty, marriage, and motherhood." In each of these photographs, a girl poses in a studio, dressed in rich silk garments and with a thick braid of jasmine flowers in her hair. Most of the photographs have a similar pose and composition: the subject looks out at the camera/viewer from the left of the scene. A mirror behind her reflects the jasmine braid, while a lush bouquet of flowers is placed on a table to the right (plates 6 and 7).

An interesting insight into the photographer's perspective was given by R. K. Narayan in a short story set in Malgudi, a small town in South India. A character in the story who is a studio photographer narrates: "The jasmine season . . . this is a heavy time for a photographer. What a lot of young girls come with jasmine buds knitted in their braids—the problem for the photographer is to photograph a girl's face and the back of her jasmine-covered head simultaneously, which is what they demand. . . . They arrive at the rate of two a minute."[3]

The primacy of the mirror in the image results in the jasmine becoming as much of a subject as the young girl. It is a rite of passage that is being constructed through the mise-en-scène. The work was also a throwback to Surekha's own memory of growing up in the South Indian state of Karnataka, where one of the most enduring images was that of the fragrance of Mysore *mallige* (jasmine).[4] At the Khoj International Artists' Workshop, where the installation was created, Surekha pasted the photographs onto mirrors that were hung on the wall. The viewer simultaneously encountered the direct gaze of the female subject as well as his or her own fragmented image reflected in the mirrors.

Both of these two installations signal the intrinsic role of photography in creating an event, not only documenting it. All major rituals across India are recorded in photographs, which over decades find their way into shops selling bric-a-brac and antiquities. Surekha's photo-installations underline the performative nature of photography and the relationship the medium has with the subject's creation of selfhood.

—LG

1 Surekha, artist's statement, accessed March 24, 2014, http://surekha.info/fragments/.

2 Surekha, conversation with Abhishek Hazra. http://surekha.info/interview-1/.

3 R. K. Narayan, "Waiting for the Mahatma," *Memories of Malgudi* (Delhi: Penguin Books India, 2002), 381.

4 Surekha, conversation with Abhishek Hazra.

PLATE 1
Fragments of a Wedding Diary, 2001 (detail)
33 found photographs
8 ¼ x 12 ¼ inches each sheet
Courtesy of the artist

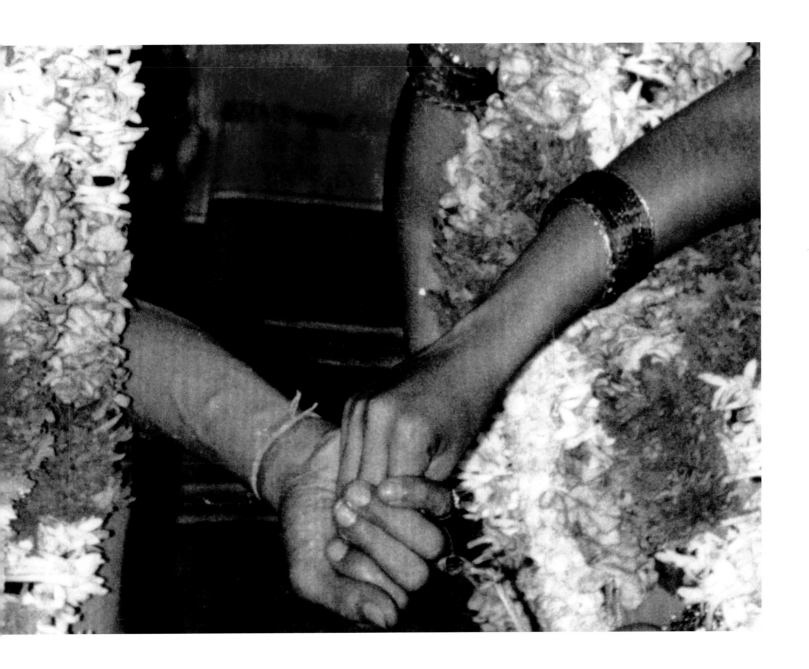

PLATE 2

Fragments of a Wedding Diary, 2001 (detail)

33 found photographs

8 ¼ x 12 ¼ inches each sheet

Courtesy of the artist

PLATE 3

Fragments of a Wedding Diary, 2001 (detail)

33 found photographs

8 ¼ x 12 ¼ inches each sheet

Courtesy of the artist

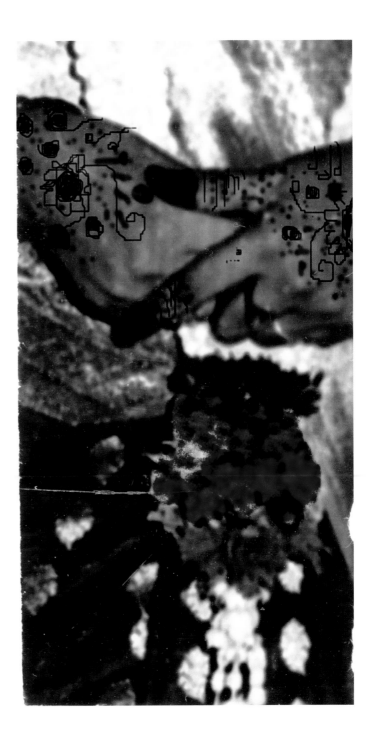

PLATE 4

Fragments of a Wedding Diary, 2001 (detail)

33 found photographs

8 ¼ x 12 ¼ inches each sheet

Courtesy of the artist

PLATE 5

The Fragrance of Jasmine, 2002
83 found photographs
10 ½ x 8 inches each
Courtesy of the artist

PLATE 6

The Fragrance of Jasmine, 2002 (detail)
83 found photographs
10 ½ x 8 inches each
Courtesy of the artist

PLATE 7

The Fragrance of Jasmine, 2002 (detail)
83 found photographs
10 ½ x 8 inches each
Courtesy of the artist

RAQS
COLL

MEDIA
ECTIVE

It is a Comfort to Gaze at You

Raqs Media Collective
It is a Comfort to Gaze at You, 2014
Medium format film
Dimensions variable
Courtesy of the artists

Mir Shamshad Ali to
Syed Karamat Ali Sahib (Delhi)
(URDU)

(MAY 1916)
Meerut Cavalry Brigade
FRANCE

...I send you a photo that was taken in April of 1916. Compare it with the photo that was taken in April of last year, and judge for yourself whether what I write is true or false. I swear again by God, that I am extremely well and comfortable...

Mahadra Lal Varna to Lala Kalivati
(Hindu's Girls' School, Lucknow,
UP)
[Hindi]

17th April, 1916
FPO. 40
France

With this letter I am enclosing a picture card showing the death of an English girl. You will notice the {man} in the picture and the young woman lying senseless on the ground in front of him. She was a nurse in Belgium and used to attend to the wounded. Nowadays, Belgium is in the hands of the Germans. The name of the young girl is Miss Cavell. She was charged with the crime of helping English soldiers escape to England [via the Netherlands], and was sentenced to death. She fainted, and the soldiers refused to fire on her body, and then the officer blew her brains out with his revolver...

24th February, 1916
Milford-on-sea

Kartar Singh (Sikh, 15th Sikhs) To
Gurdit Singh (Raswind, Punjab)
[Gurmukhi]

And my friend, this is the photo of our king's granddaughter... She has distributed her photo amongst the Sikh brethren at the depot [Milford] on the evening of the 23rd february at five o'clock...

Jalal-ud-Din Ahmad
(Hindustani Muslim)
to Haji Saadat Mir Khan
(Etmadpur, UP, India)
[Urdu]

Rouen
FRANCE
14th October, 1915

Today I purchased some pictures in great haste and am sending some of them to Bashir. I could not find any more pictures of that woman, who stands, clad in armour, with her glance turned upward toward heaven, and [who] seems to be a very fine, handsome, young woman, I am looking for them and have searched many shops. Four hundred years ago that woman gained some notable victories in the war against the English. However, she was caught and the English burnt her alive. I think that is why the sale of her picture has been stopped, lest it should affect adversely the present friendship between the French and the English...

Mir Jaffar (Punjabi Muslim) to
his niece (Amritsar District, Punjab)
[Urdu]

16th May, 1916
Ambala Cavalry Brigade
France

I send you the picture of a girl equipped for battle.
Certainly nowadays honorable young girls are making
themselves fit for battle, and for this reason – that they
may, if required, fight for the king and the country... I
went to London for ten days and returned today. I was
very pleased with the trip... In one place I saw wax figures
the size of a man, which are so wonderfully made that it is
impossible to say whether they are real people or not...

24th May, 1916
Secunderabad Cavalry Brigade
France

Gholam Rasul Khan (Hindustani
Muslim)
to his father Mohamed Nawas Khan
(Aurangabad, Gaya District?, Bihar)
[Urdu]

The photo you sent me is near me. When my thoughts turn towards you and look at it and see all three of you, I become happy and my grief disappears. You say it [the photo] is a useless thing, but for me it is worth all the money I possess. I don't see you in my dreams and, for this reason, it is a comfort to me to gaze you in your picture...

In the Theater of Memory

The Work of Contemporary Art in the Photographic Archive

Faces within Faces

The Francis Galton Collection sits in the Science Library of the University College of London. Galton (1822–1911) was a Victorian scientist who, among considerable additional achievements, invented psychometrics and pursued extensive studies of the controversial and discredited "science" that he called eugenics, basing much of his research on phrenology and using measurements to indicate ethnic types and thereby predict behavioral characteristics.[1]

By bringing us face to face with Galton's haunting archive of photographic portraits, our video installation *The Surface of Each Day is a Different Planet* (see Raqs, plates 3–5) considers, among other things, the dense presence of human beings in archival traces. That encounter finds its way into the installation's spoken text. The silence of hundreds of faces begins to yield. Before we enter into the central arguments of this essay, we would like to present an extract from the spoken "commentary" that accompanies this work.

Faces light up like coal in a brazier. Ablaze, radiant, pensive, troubled, hungry, calm, assured, insane, inflamed. Piling eye upon eye, ear upon ear, wrinkle upon wrinkle, feature upon feature, smile upon grimace, Francis Galton, mathematician, statistician, polymath and Victorian colossus, wants to see his picture of the world when he looks at a crowd of faces. His world is small, his laboratory crowded, his assistants are tired, their calipers are falling apart. They have never measured so many in so little time. When Galton files away thousands of faces or fingerprints into numbered and indexed folios, he isn't just creating a repository of physiognomies. He is collecting and classifying the content of souls, turning, he thinks, the keys to the mysteries of the locked cabinet of human character.

But the "ghost" image of a composite of madmen from Bedlam has strangely gentle eyes. Galton's wager—that if you were to stick the faces of eighty-six inmates of the Bedlam asylum on top of each other, you would end up looking into the eyes of madness—has gone oddly awry. These criminal composites produce a saintly icon. A quest for the precise index of what Galton thinks is ugliness in a row of sullen East London Jewish schoolboys yields amazing grace …

The individual photographs were taken with hardly any selection from among the boys in the Jew's Free School, Bell Lane. They were the children of poor parents. As I drove to the school through the adjacent Jewish quarter, the expression of the people that most struck me was their cold, scanning gaze and this was equally characteristic of the schoolboys. The composites were made with a camera that had numerous adjustments for varying the position and scale of the individual portraits with reference to fixed fiduciary lines, but so beautiful the results of these adjustments are, if I were to begin entirely afresh, I should discard them, and should proceed in quite a different way. This cannot be described intelligibly and at the same time. — Francis Galton, "Notes on Photographic Composites," undated, Galton Papers, University College of London

…the faces and fingerprints whisper a thousand secrets to Galton, but they do not let him in on their greatest mystery. The face of the crowd is a face in the crowd, fleeting, slippery, gone before you blink, always gentle, always calm, always someone you think you can recognize.

The Absent Time Between Exposures

One of the things that has struck us whenever we have browsed in an archive of early ethnographic and anthropometric photographs, or even portraits, is the exposure time needed for these images. Daguerreotypes and early glass negatives, which constitute most of the material that we have looked at, required that the subject sit or stand still for lengths of time that would try our patience today.

The nineteenth century saw an explosion of anthropometric photography. Every "race" was photographed and measured, down to the last fingernail. In some cases, such as the inhabitants of the Andaman Islands,[2] the photographs in archives around the world today outnumber the actual living people. The population of images has by now outnumbered that of bodies.

When looking at these images, like during an extended research residency at the International Institute of Visual Arts, London, in 2006, where we encountered several visual anthropology and photographic archives, including the Galton Collection, we have always been struck by the thought that it would have required an elaborate application of coercion and restraint to ensure that an Adamanese or other subject would stand still against a grid for the requisite exposure time. It was this understanding that helped us formulate the ideas that informed the making of a work such as *The Surface of Each Day is a Different Planet*. We realized that the achievement of images as studied as the ones we were looking at in these archives demanded that the subject deliver up a forced, choreographed passivity. Every photograph in any such archive is a record of the arrested dance of power.

This quality becomes even more interesting when we realize that several contemporary photographic practices are intimately tied up with the production of legal and illegal presences. People photographed for certain purposes must generally be photographed in certain ways—for example, for a passport or for forensic requirements. Sometimes photography is not permitted. For example, most public utilities in Delhi display prominent "Photography Prohibited" signs. Conversely, in many spaces, such as on the metro in Delhi, the ubiquity of surveillance cameras means it is impossible not to be photographed. In some spaces, like in an unauthorized or illegal urban settlement in Delhi, the presence of a person with a camera is viewed as an opening gambit in a maneuver of surveying that will ultimately end with the razing of the neighborhood.

The surface of the photograph then has to be seen as a contested terrain. Appearing on it or disappearing from it is not a matter of visual whimsy, but an actual index of power and powerlessness. Portraits of "wanted" and "missing" persons reveal in their eyes a strange blankness, a pronounced lack of intensity. They are there, in the picture, but they look as if they were not there.

The temperature of truth varies. Sometimes, when it is too hot to handle, one needs to cool it down with distance and irony. Sometimes, so that a truth can endure, one needs to surround it with an ambient coolness so that the truth endures. Naked truth is fragile, brittle, and short-lived. Working with facts is sometimes a prelude to a long process of deliberation about the conditions of truth storage. These deliberations can take on a character of productive fantasy that serves better than any conservation means to prevent an item from being lost in the archive and forgotten.

Also, often, when we are dealing with "facts," we come to realize that the annotations that produced the facts are themselves ruses, often designed to paper over a systematic amnesia. The inscriptions in the archive are also instances of overwriting and erasure. When looking at a face in a photograph in an archive, we are sensing the ghosts of several other faces as well. These absences and presences constitute a strange, spectral composite.

The Camera as Witness and Actor

The arts and sciences of memory changed the moment photography entered the consciousness of our time. Before then, it was possible to dispute whether or not an event had occurred. After photography, the debate can no longer be framed in those terms. The question is no longer about whether something did or did not occur, but whether a camera was on hand to record it. The camera is both witness and actor. Photography, especially in the archive, is a form of theater.

As in any performative genre, photography occasionally demands suspension of disbelief. One is not asked to simply see, but also to believe what one is seeing. The photographic historian and archivist Joan Schwartz wrote:

Photography was not just a new way of seeing; it was a new way of believing. It was ...a "technology of trust"; or what record keepers would consider a "trustworthy information system" ...[and yet] the rhetoric of transparency and truth—or in archival terms, authenticity, reliability and objectivity—that came to surround the photograph raised serious questions about the very nature of truth, particularly in relation to art. At the surface of the problem was the degree to which a mechanical device could produce a truthful picture of reality.[3]

Following from this, it could be said that photographs are not traces of truth per se because they are themselves implicated in the production of what has come to be known as being true.

It is in this vein that John Tagg in his influential book on history and photography, *The Burden of Representation*, wrote: "Photographs are never 'evidence' of history, they are themselves the historical." In other words, the "real" as the philosopher Jacques Rancière would have it, is an "effect to be produced" rather than a "fact to be understood."[4] What makes history is not necessarily what gets historicized. The archival photograph both makes history, in the sense that it constitutes historical "evidence," yet it simultaneously also unmakes history because it excludes whatever falls outside its frame and the time it took to make the exposure that resulted in the photograph. The archival photograph contains both the presence as well as the absence of the historical within its surface. Consequently, reading the photograph is to read into all the things it says, and at least into some of the things it does not say. Listening to its silences is an act of the imagination. It is here that the artist is able to do a few things that the historian is prohibited from doing.

How does one relate this question of the active production of a sense of the real to the practice of contemporary art? Art, as we understand it, does not "show" reality, it "produces" truth. The truths produced by art are not necessarily mimetic, nor do they lay claim to comprehensiveness or completeness. But the succor that art brings to the senses has something to do with a feeling of the repleteness of an experience, even when that experience is presented elliptically, enigmatically, and with an acute awareness of the absence of the empirical datum.

What does a photographic archive do to an artist who enters the archive? What does the artist make of the accumulation of history that the archive represents? What work can contemporary art do in the archive? In some regards, the question of the performance of the ontological status of the photographic trace in an archive is made most apparent when contemporary art meets the archival photograph.

The art historian and critic T. J. Demos, writing about the paradoxical relationship between truth, evidence, and the production of contemporary art, stated:

To produce the real as an effect means to engage in a process of contemplation and construction, of gradual understanding that brings changes in perception. Poetry, as evidence, then suggests a commitment to emancipation via continual experimentation, creative invention and self-transformation. Contemporary art, as both a practice and a discourse, defines a privileged realm in which the complexities of this conclusion, the sometimes paradoxical outcomes and the radical possibility of repositioning evidence as a new poetic paradigm—can be animated and addressed.[5]

To consider the photograph in the archive, then, is to consider not just a problem of history, but also a question of the poetics of the real, of memory and oblivion.

The Bare Bones of a Picture

The archive shapes facts. It produces the narrative and the story that the facts are made to tell. In other words, the archive, by its sequential, cross-indexed, and jussive ordering of notings and data, can also render a figment of the imagination into a fact, or at least blur the borders of fact and fiction. One possible task for the artist then is to prize the archived fact back into the realm of interpretation, through hermeneutic procedures that privilege the imagination. It is to ask what gets forgotten, or what can be recovered only through fantasy, through speculation, through the oddness, humor, and irony, whenever the archive produces its fixity of memory.

The drama of the photograph in the archive consists in this tension between the claim to truth and the ruses necessary to the making and contesting of this claim. This fact has come alive to us most recently while working with the remarkable photograph *Interior of the Sikanderbagh after the Slaughter of 2,000 Rebels by the 93rd Highlanders and 4th Punjab Regiment. First Attack of Sir Colin Campbell in November 1857, Lucknow,* March or April 1858, in the collection of the Alkazi Foundation for Photography.[6] The photograph was taken in 1858 by the itinerant photographer Felice Beato as part of an album of scenes related to the Indian Mutiny of 1857. Beato's sojourn in India was bracketed by stints in the Crimean War and the Second Opium War. Our own quotation of the photograph first took the form of a sustained forensic reflection that constitutes a significant section of the work *Seen at Secunderabagh* (figures 1–3).

Sikanderbagh, or Secunderabagh, is a relatively small, walled pleasure garden on the eastern outskirts of the northern Indian city of Lucknow. In the siege of Lucknow during the Mutiny of 1857 that occurred in India among the forces of the British East India Company, Sikanderbagh saw some of the fiercest fighting.

The photograph shows the pavilion within the garden where, as Beato noted dispassionately on the image, "two thousand Indians were mercilessly slaughtered in November 1857, by the 93rd Highlanders and the 4th Punjab Regiment, in the course of the attack led by Sir Colin Campbell." This photograph was taken in March or April 1858, roughly four months after the actual battle.

At first glance, the picture suggests a melancholic sentimentality, stately nostalgia for a time gone by, or the fleeting resonance of time arrested: a Baroque ruin, men in studied poses, a fine horse. But a closer look reveals that the photograph seems to have been taken in full light, perhaps at noon, when there were no shadows to obscure the fact that the "scene" is the result of a careful act of arrangement. The skeletons are clean, picked to the bone, white against the dun earth, as they would be in a painterly tableau. Yet, these stark skeletal remains could not have been achieved between November and March or April of a northern Indian winter. Had they been picked clean by scavenging animals, the skeletons would not have remained so well integrated. It is possible, even highly likely, that they are actually props, macabre prosthetics or the bones of other people brought

in to stage the scene because the originals were missing or just inadequate for a decent picture. Whatever the case, they have been placed with a thought to symmetry and order, just as the carefully considered attitudes of the men suggest the illusion of spontaneity.

Who were these four men? Were they involved in arranging the bones, or even in digging them up, carrying them, and placing them at the photographer's bidding? What testimonies do bleached bones and a crowd of disinterred skeletons offer up to posterity? What can the bones tell us?

In attempting to "listen" to the drama of this photograph, we found ourselves drifting from the archive to the theater. This is partly because this photograph, more than anything else, helped us understand that the archive is a theater, that the witness is also an actor.

The Archive of Tomorrow

Today, photographic images come at us not as static presences, but as kinetic elements, as a set of kinetic envelopes; they flicker onto ubiquitous screens: televisions, computer monitors, mobile phones, tablets. Wherever we look, there are images—as fetishes, as memorabilia, as ornaments, as seductions, as instruments of governance, as items of forensic evidence, in newspaper or magazine stories, as posters for missing or wanted people pinned to a wall, as advertisements on the curving surfaces of a metro station.

The photograph and the photographically inflected object have a very different status from the commemorative or iconic function that they might have had in an earlier time.

Stored in hard drives, deleted and catalogued repeatedly, scanned, resized, drained or saturated in terms of color, photographs are both the substance and the detritus of our existence. These layers of meaning will fill the photographic archives of tomorrow, whose contingency and volatility will only underscore the question of finding a poetics appropriate and commensurate to the problem of understanding the archival act. As Sven Spieker argued:

in the archive we encounter things we never expected to find; yet the archive is also the condition under which the unexpected, the sudden, the contingent can be sudden, unexpected and contingent. Or, differently put, nothing enters the archive that is not in some sense destined to be there from the moment of its inception.... Contingency is not the same as organized, yet its precise morphology can be detected only by accident (literally). The archive does not give access to history: it is, or aims to be, the condition of historicity itself. The archive therefore is not simply a departure, a cipher for the condition of innovation: it gives a name to the way in which the new is also a return, an iteration in the true sense of the word.[7]

FIGURE 1

Still from *Seen at Secunderabagh*, 2011
Performance with video monitors,
projections, text, sound, and treated
archival material
Dimensions variable
Video run time 50 minutes
Courtesy of the artists
Photograph Armin Bardel

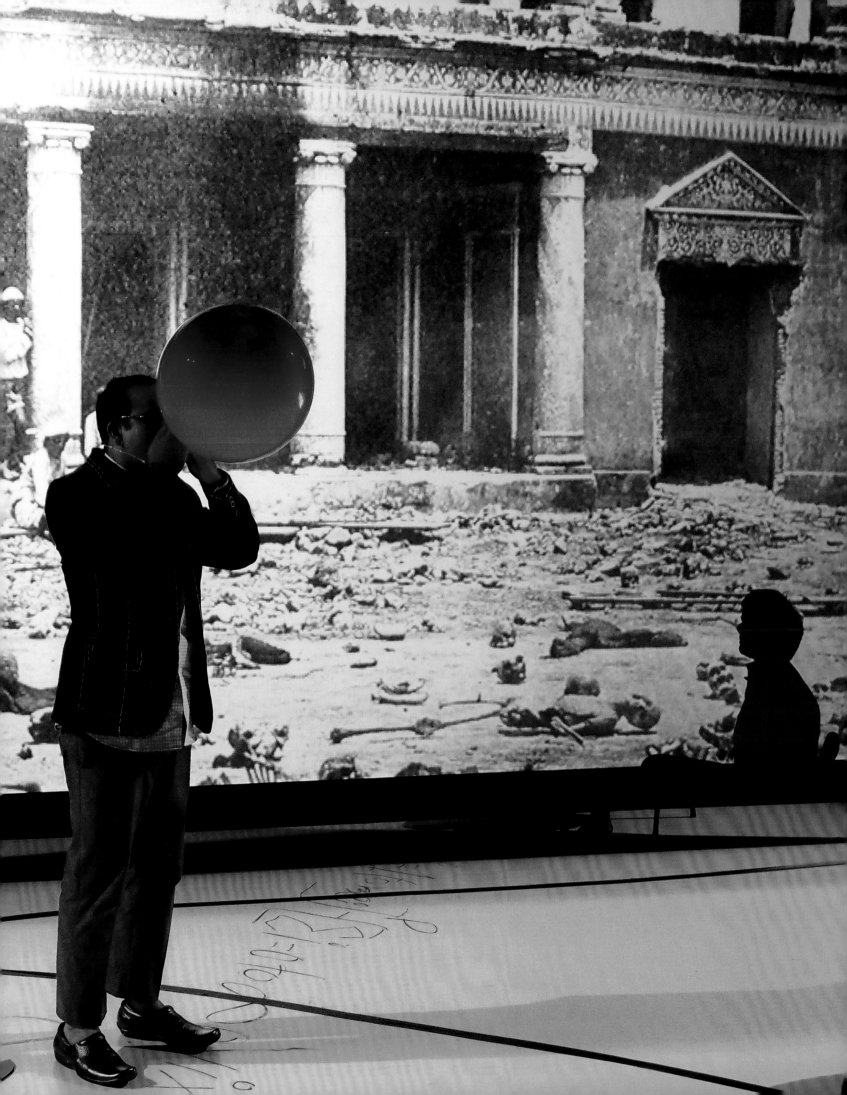

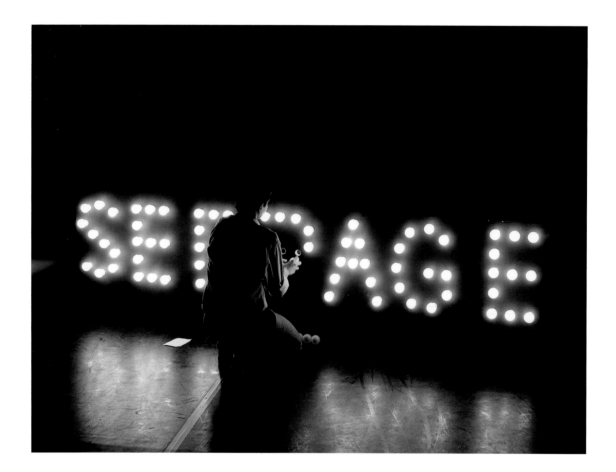

When detritus and substance coincide with an increasing regularity—as we believe they do in today's world, in which somebody's urban renewal is the destruction of somebody's habitat—we come face to face with an interesting dilemma: that of the impossibility of being able to make "constitutive" images that build desired or desirable realities. The images that yield themselves to us do not in themselves create opportunities for redemption, nor do they offer utopian possibilities. Nor is it possible for us to view them as extensions of our personal, subjective visions. We find it difficult to make images do the work of manifestos, pamphlets, or diaries. *What we are able to do is to make images that work as notations that encrypt a set of rebuses. That allow the new to return, and that enable us to read the returned as something new.* Reading an image in this manner, which is one of the first steps one can take as an artist when confronted with an image retrieved from an archive, is to read into its *absences*, and (therefore) into its *potentialities*. Just as a set of notes points to realities larger, more fulsome and complex than the mere act of their listing allows for, so too, reading a photograph that functions as notation involves knowing and understanding that what we see also contains a great deal that is amiss, that has faded, degraded, disappeared, or is in a condition of distressed visibility. The less-than-visible elements in an image are just as interesting as the visible; sometimes, they may be much more arresting.

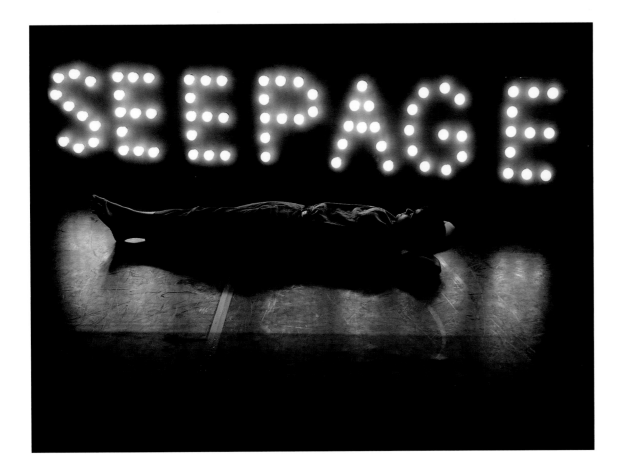

Walter Benjamin, in his "Short History of Photography," wrote conspiratorially of photographs as indices of "scenes of a crime," saying prophetically (as evidenced today by mobile phone cameras) that, "the camera is getting smaller and smaller, ever readier to capture fleeting and secret moments whose images paralyse the associative mechanisms in the beholder."[8] This led in his view to a situation wherein "photography turns all life's relationships into literature." If we take this view seriously, we have to consider photography first of all as the literature of the relationship between visibility and obscurity, and as a commentary on the tension that binds the barely visible to our retinal surfaces.

Working with images today is working with an archive that grows around us by the second. Photographs hang on walls, become monumental icons, get lost in files and folders in cabinets. Some are worn as pendants or turn up on gravestones. Others end up in the garbage. Probably most get sent into photographic digital limbo, when a million times a second the delete button is pressed on a digital camera. Wherever they are found, and however they circulate, the photographs index distance and proximity, intimacy and difference; they instantly tell us stories about comfort and

FIGURE 2

Still from *Seen at Secunderabagh*, 2011
Performance with video monitors, projections,
text, sound, and treated archival material
Dimensions variable
Video run time 50 minutes
Courtesy of the artists
Photograph Armin Bardel

FIGURE 3

Still from *Seen at Secunderabagh*, 2011
Performance with video monitors, projections,
text, sound, and treated archival material
Dimensions variable
Video run time 50 minutes
Courtesy of the artists
Photograph Armin Bardel

discomfort and whether or not the presence of the photographer was welcomed, challenged, ignored, or merely entertained.

Our understanding of the photographic archive of the past and the contemporary practices of photography infect each other. The moment of taking a photograph today, and the moment of looking at a photograph taken in the past, produce similar fields of forces that get activated in the interval between the click of a shutter in a camera and the filing of a photograph in a hard drive or an archive. Between these two instants lies an entire history of the performance of a claim to truth. The photograph is a chronicle of that history, and our role as artists today is not to repeat that claim but to subject it to an imaginative trial. This is what has made us move from the archive to the theater,[9] with the photograph as our guide.

1 For more on Galton, see Martin Brookes, *Extreme Measures: The Dark Visions and Bright Ideas of Francis Galton* (New York and London: Bloomsbury Publishing, 2004).

2 See Elizabeth Edwards, ed., *Anthropology and Photography* (New Haven, Connecticut: Yale University Press, 1994).

3 Joan M. Schwartz, "Records of Simple Truth and Precision: Photography, Archives and the Illusion of Control," in Francis X. Blouin Jr. and William G. Rosenberg, eds., *Archives, Documentation and Institutions of Social Memory: Essays from the Sawyer Seminar* (Ann Arbor: University of Michigan Press, 2007), 71.

4 John Tagg, "Evidence, Truth and Order," in *The Burden of Representation: Essays on Photographies and Histories* (London: Macmillan, 1988), 65.

5 T. J. Demos, "Poetic Justice: On the Art of Evidence," in Diana Baldon and Daniela Zyman, eds., *The Question of Evidence* (Vienna: Thyssen-Bornemisza Foundation, 2008), 53.

6 For more on this photograph and the other photographs of the Andamanese, see Zahid Chaudhary, "Phantasmagoric Aesthetics: Colonial Violence and the Management of Perception," in *Cultural Critique* 59 (Winter 2005), University of Minnesota Press, 63–119.

7 Sven Spieker, *The Big Archive: Art from Bureaucracy* (Cambridge, Massachusetts: MIT Press, 2008), 173–74.

8 Walter Benjamin, "Short History of Photography," trans. Phil Patton, *Artforum* 15, 6 (February 1977), 46–51.

9 This move is evident in the process that has led to our collaboration with the theater director Zuleikha Chaudhari and the actor Manish Chaudhari, with whom we produced *Seen at Secunderabagh*, an experimental theater performance based on our text responding to Felice Beato's eponymous photograph, which premiered at the Kunstenfestival, Brussels, in May 2011.